Hand Lettering

CREATIVE ALPHABETS
FOR
ANY OCCASION

Thy Doan Graves

ST. MARTIN'S GRIFFIN
NEW YORK

www.stmartins.com

The written instructions, photographs, designs,
patterns, and projects in this volume are
intended for personal use of the reader and
may be reproduced for that purpose only.

Library of Congress Cataloging-in-Publication
Data Available Upon Request

ISBN 978-1-250-12205-6 (trade paperback)
e-ISBN 978-1-250-12206-3 (e-book)

Our books may be purchased in bulk for
promotional, educational, or business use.
Please contact your local bookseller or the
Macmillan Corporate and Premium Sales
Department at 1-800-221-7945, extension 5442,
or by e-mail at MacmillanSpecialMarkets@
macmillan.com.

First U.S. Edition: February 2017

QUAR.HLTR

Conceived, designed, and produced by
Quarto Publishing plc
The Old Brewery
6 Blundell Street
London N7 9BH

Senior editor: Chelsea Edwards
Senior art editor: Emma Clayton
Editorial assistant: Danielle Watt
Picture researcher: Sarah Bell and
Susannah Jayes
Art director: Caroline Guest
Designer: Martina Calvio
Creative director: Moira Clinch
Publisher: Paul Carslake

Color separation by Cypress Colours (HK) Ltd,
Hong Kong

Printed in China by Toppan Leefung Printing Ltd

10 9 8 7 6 5 4 3 2 1

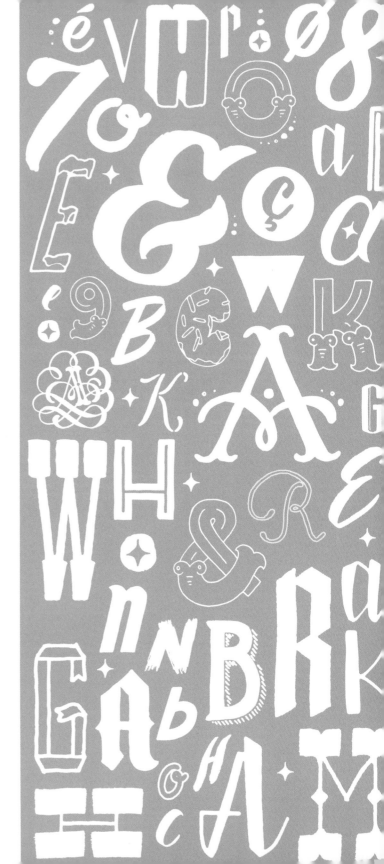

CONTENTS

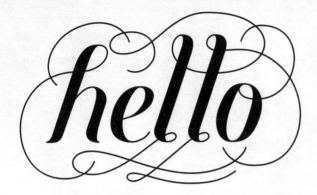

Putting time in the studio.

Hand lettering has always been intriguing to me, in its many forms and styles, and in the beauty of its imperfections. My love for it was sparked during my time as a sign maker at a local Whole Foods Market, years ago in Utah, and has since grown with my desire to experiment with new mediums and surfaces. I've created a line of products for my Big Cartel shop and completed client projects as small as logos and as large as office murals. Some examples of my work are featured on the opposite page. Now, as a designer based in Boston, hand lettering is a wonderfully rich tool that adds personality and versatility to my work.

This book contains a heap of different alphabets for you to experiment with and be inspired by. There are plenty of practice pages for you to combine and try your hand at any alphabet you see, or even to create your own! You'll also find some wonderful work from other lettering artists that have kindly contributed to this book. I hope you'll find the same kind of joy with hand lettering as I have in your journey to learn the craft. While there are guidelines, hand lettering offers so much room for flexibility to make it your own, and for plenty of fun!

The only crew I roll with.

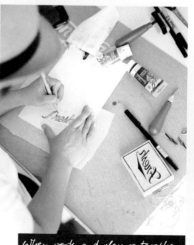

When work and play go together.

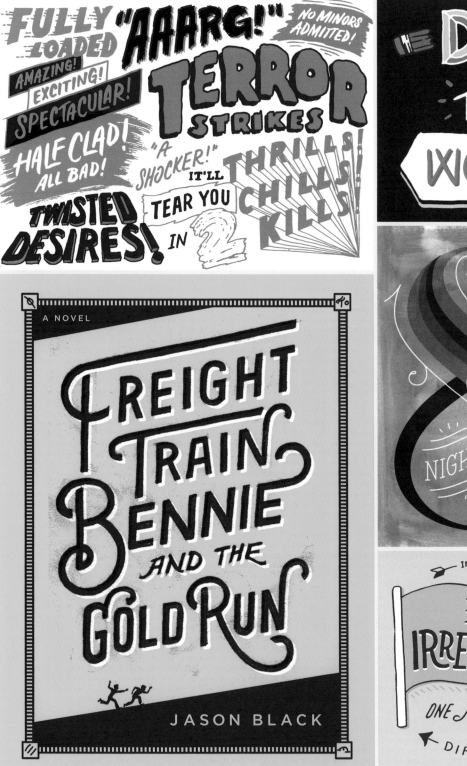

GALLERY

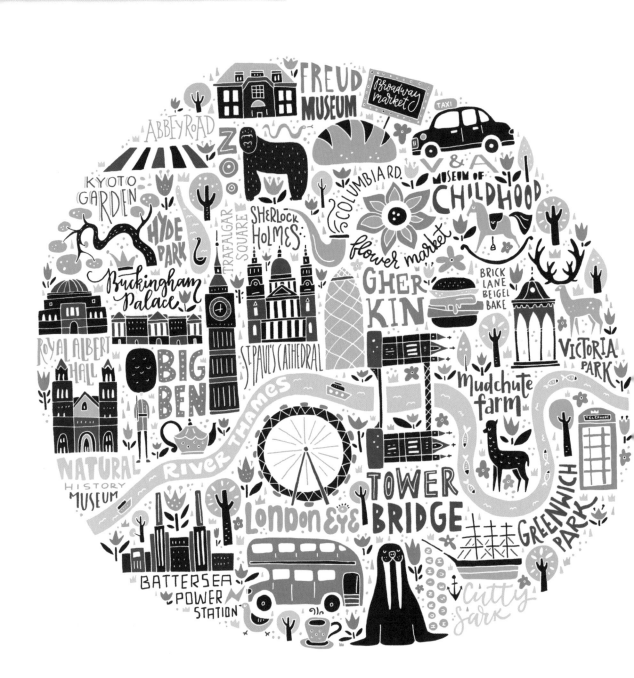

▲ *Map of London*, Olga Zakharova
A wonderful hand-drawn map that combines illustration and lettering to highlight iconic places and things in and around London. Pencil drawn, refined with fine-tip pen, scanned, and then finished in Adobe Illustrator.

▶ *New York City*, Scott Biersack
Vectorized informal brush-script drawn to announce Scott Biersack's move to New York City. Originally drawn and refined by hand with a pencil and then further edited in Adobe Illustrator.

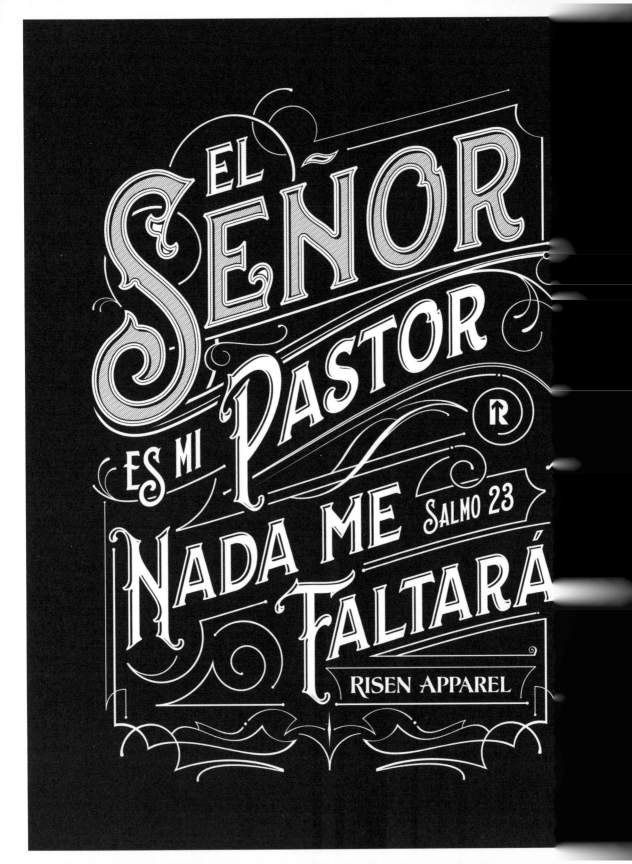

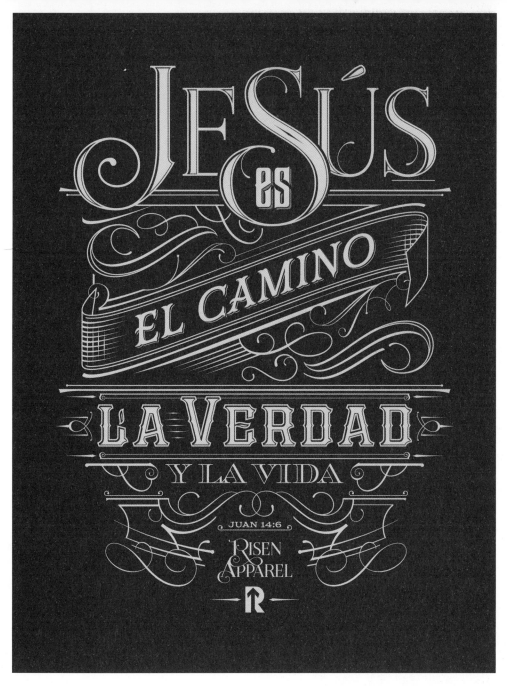

JESÚS es EL CAMINO LA VERDAD Y LA VIDA

JUAN 14:6

RISEN & APPAREL

◄ *El Señor es mi Pastor*, Tomasz Biernat
Simple bible verse created in styles inspired by vintage engravings, woodcuts, and ornate vintage book covers that require very precise line work to create this beautiful style of lettering.

▲ *Jesus es el Camino*, Tomasz Biernat
This bible verse is from a similar series and is created in styles inspired by vintage engravings and ornate book covers.

► **Ampersand, Martina Flor**
A lovely ornate ampersand created for a lucky card as a holiday gift to her friends and clients. The final piece was printed in glitter gold.

El Bandarra Vermut

▲ *El Bandarra,* Ivan Castro
Logotype inspired by traditional vintage Spanish vermouth packaging, as well as vintage soda bottles and brands. Created by hand and finished digitally in Adobe Illustrator.

Viejóvenes

▲ *Viejóvenes,* Ivan Castro
Victorian style lettering for an old style poster, advertising a comedy show. Created by hand and finished digitally in Adobe Illustrator.

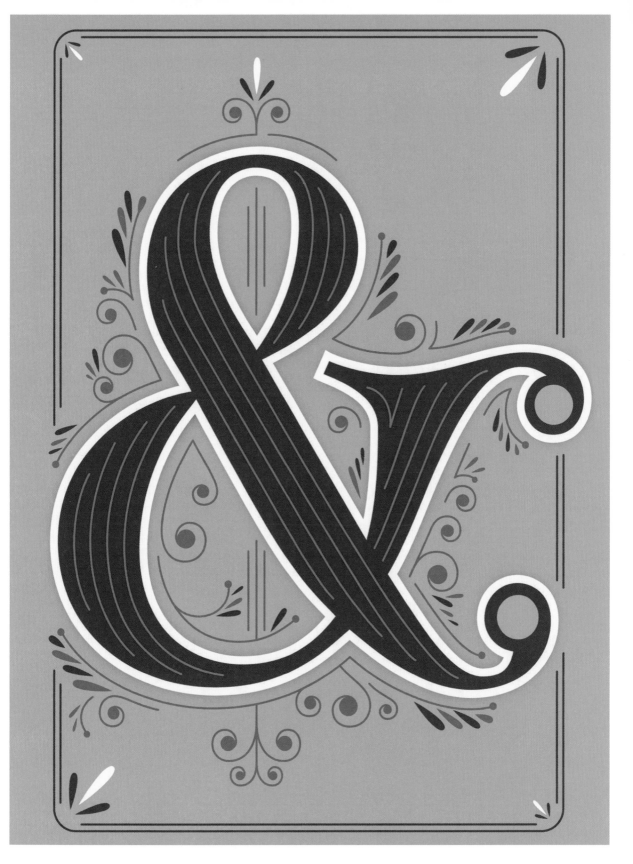

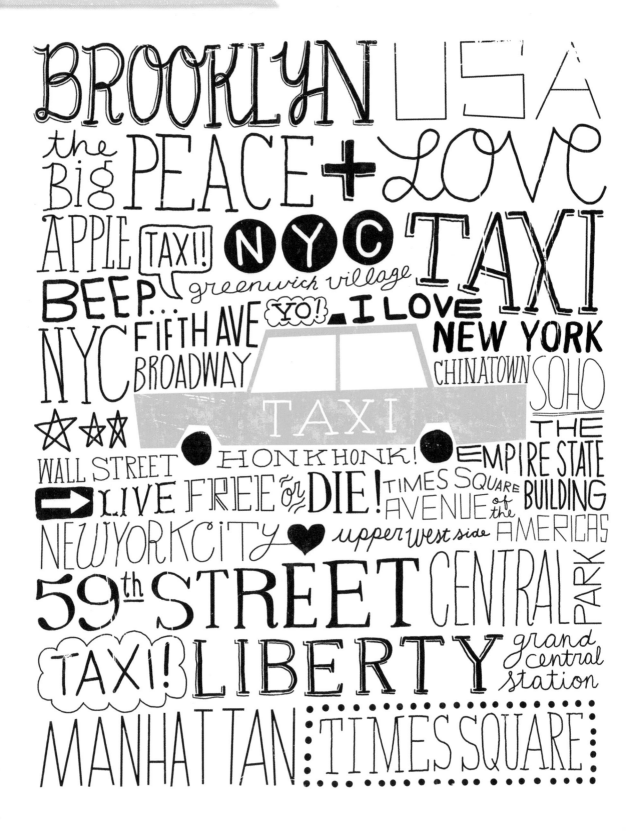

◄ *Iconic New York Taxi*, **Michael Mullen**
A fun greeting card meant to celebrate the energy and buzz of New York City. Digitally drawn in Photoshop and embellished with handmade textures.

► *Saltmine Theatre Thank You Card*, **Emma Skerratt**
A thank you card commissioned for supporters of the Saltmine Trust. This piece was created in ink and then colored digitally.

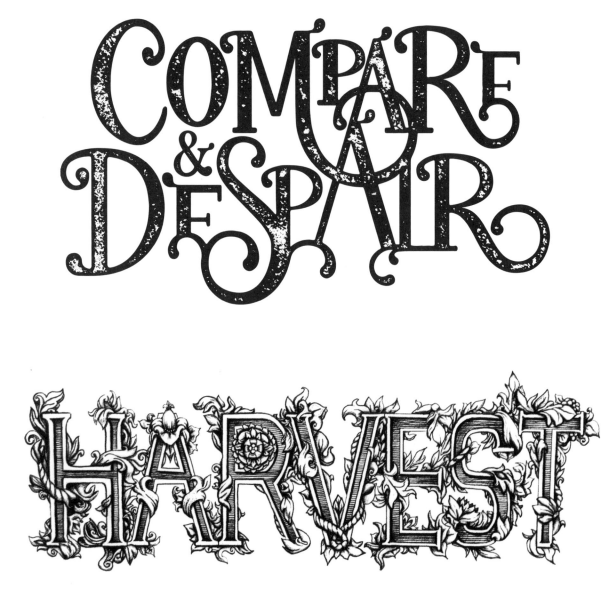

▲ *Compare and Despair*, Noah Camp
Designed for a personal blog post, this lettering piece is created using pencil and paper to start, then scanned and finished in Adobe Illustrator and Photoshop.

▲ *Harvest*, Erin Marlow
Highly illustrative lettering piece that offers so much visual fun- the textures and detailed foliage are created with pencil and they really bring the word to life.

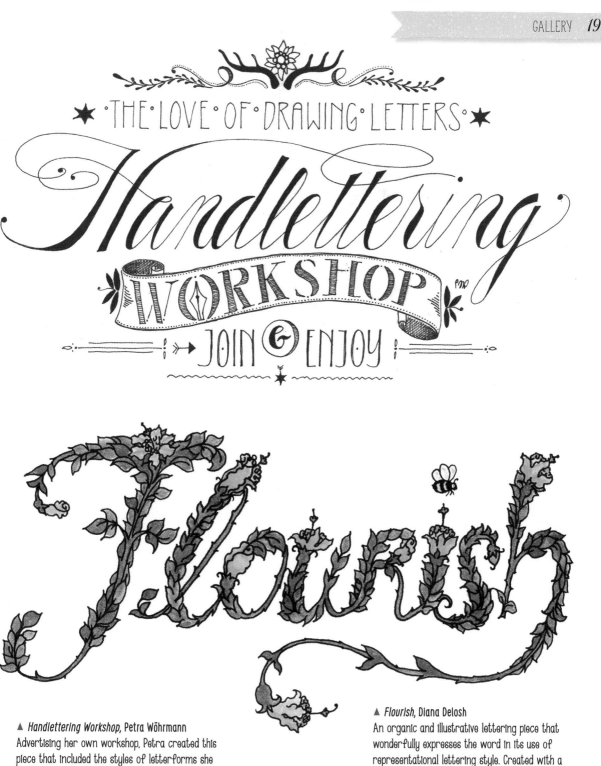

THE · LOVE · OF · DRAWING · LETTERS

Handlettering WORKSHOP JOIN & ENJOY

▲ *Handlettering Workshop*, Petra Wöhrmann
Advertising her own workshop, Petra created this piece that included the styles of letterforms she likes to practice, while also including some beautiful elements that are commonly found in the Alps.

▲ *Flourish*, Diana Delosh
An organic and illustrative lettering piece that wonderfully expresses the word in its use of representational lettering style. Created with a fine-tip pen on watercolor paper and then painted with transparent colored ink.

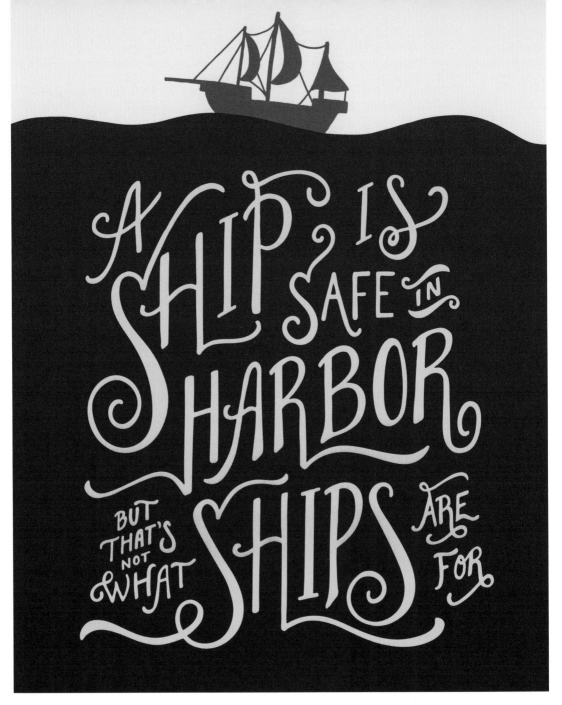

A SHIP IS SAFE IN HARBOR BUT THAT'S NOT WHAT SHIPS ARE FOR

▲ *A Ship Is Safe in Harbor*, Jonelle Jones
Inspired by those brave enough to leave the shore for big adventures, this lovely piece was created with pencil, then digitized and finished as a giclée fine art print.

► *Home Is Where You Park It*, Alexandra Snowdon
Inspired by words painted on the back of an old camper van, this piece captures the love and comfort of home with the decorative style of letters and illustration. Created in pen and then finished digitally.

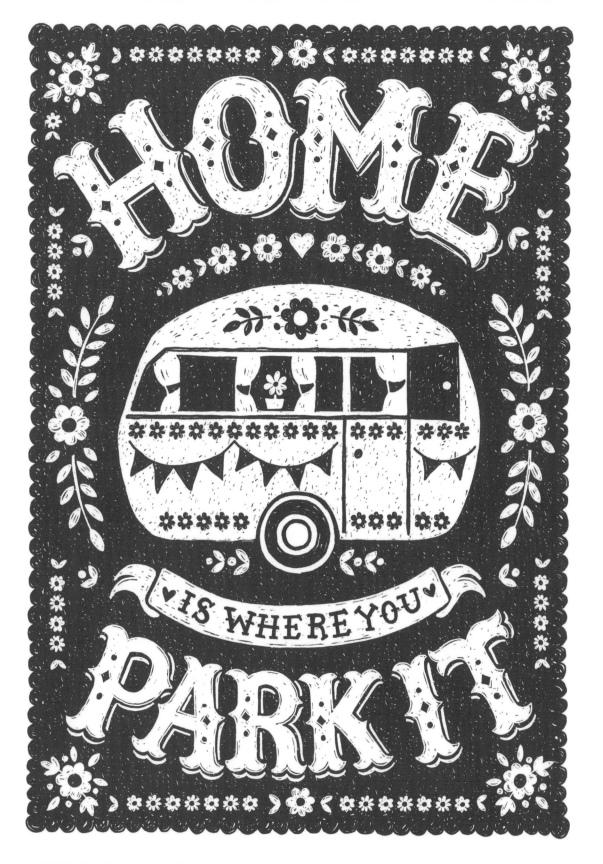

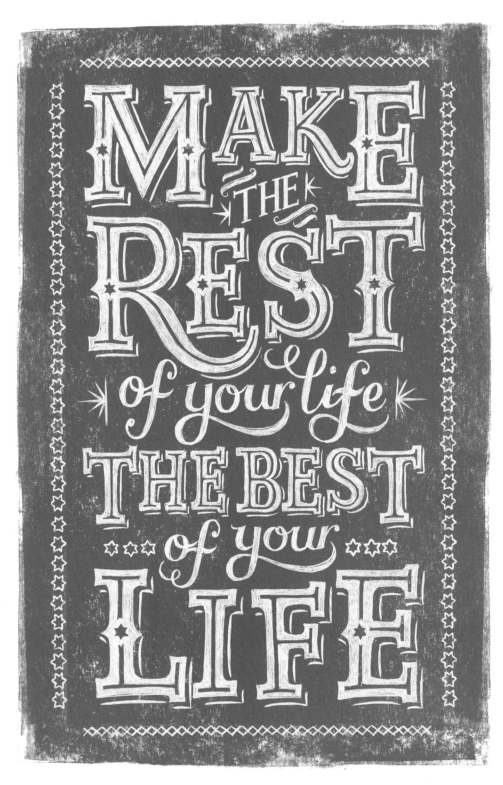

◄ *Make the Rest of Your Life the Best of Your Life*, Alexandra Snowdon
Inspired by words she saw on a chalkboard sign outside of a coffee shop, Alexandra drew these letters in pencil and refined it digitally to create a chalkboard effect for the final piece.

► *Amazing World*, Olga Zakharova
Inspired by the love in her life, this piece integrates illustration and lettering. Hand-drawn pencil, refined with fine-tip pen, scanned, and then colored in Adobe Illustrator.

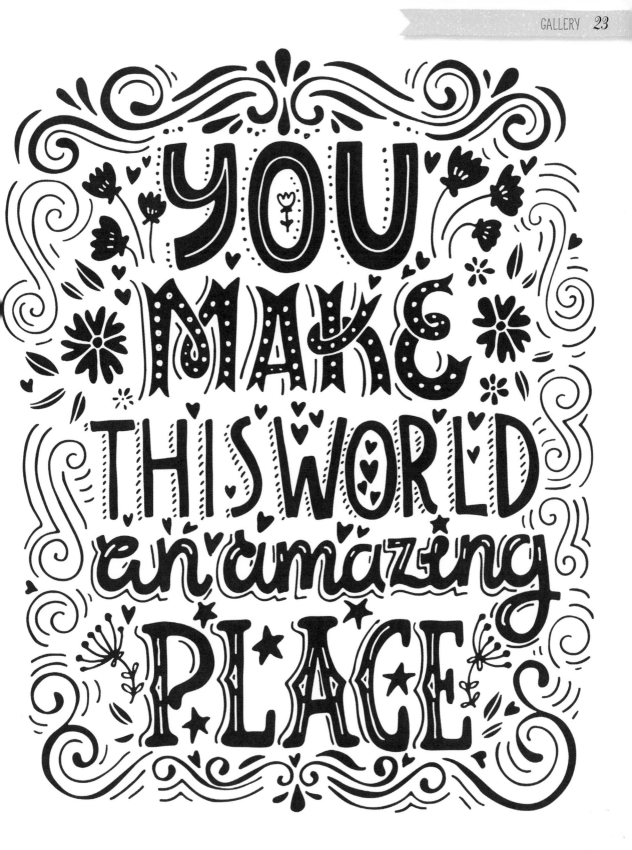

TOOLS, MATERIALS & TECHNIQUES

WHAT IS HAND LETTERING?

There is certainly ample confusion over what is and isn't hand lettering. I've had people look at my hand-lettering work and say "I love the font you're using." This is wrong, but I know they don't know better. There is a big misconception that calligraphy, typography, and hand lettering are all the same thing. People tend to use the terms them interchangeably, so let's go ahead and clear that up.

CALLIGRAPHY

This is the art of decorative handwriting with an emphasis on the fact that it's written. These letters are artfully formed with fairly specific tools that include broad tips, ink nibs, or brushes. There are many beautiful styles, each of which follows a structured form that relies on consistent execution.

Carpe Diem

TYPOGRAPHY

Typography is the art of the printed word. It involves the arranging, styling, and appearance of printed letters. This is, by far, the most calculated form of the written word, since legibility is the primary focus. Typography dominates publications such as printed books, magazines, and articles.

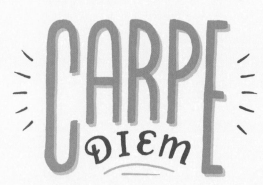

HAND LETTERING

This is where the fun comes in and some of the rules go out the window. Simply put, hand lettering is the art of drawing letters. You can create your letterforms in styles that fit your need rather than being restricted to a certain typeface or calligraphic solution. The imperfections and flexibility render much richer results.

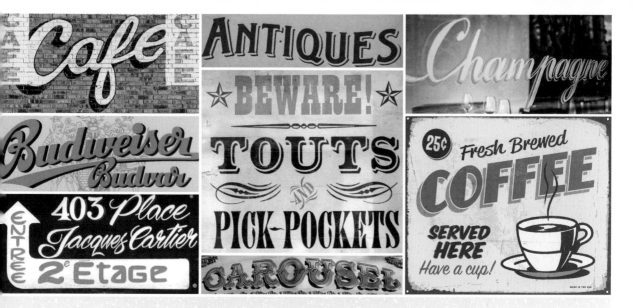

FINDING INSPIRATION

There is no one specific place I search for inspiration. My love of antique shopping, record-store diving, and of beautiful signage and packaging certainly features heavily. My space is littered with things I've collected over the years that carry beautiful letters. I highly encourage people to get outside to find inspiration, especially if you can wander through towns with interesting storefronts and old signage to be inspired by.

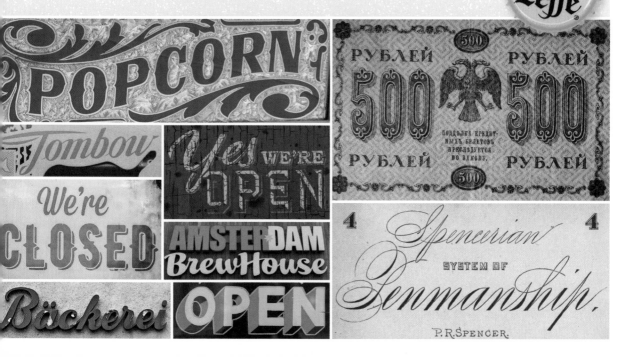

TOOLS AND MATERIALS

One of the great things about hand lettering is that you don't need lots of fancy materials to get started. As you practice and get more comfortable you can try out new tools and learn about the different results they may render. Until then, here are some of the tools you might consider getting hold of.

PENS

Depending on your confidence and experience, you might use pens for all stages of your letter work, or you may prefer to map out your letters in pencil first, then go over your pencil lines or fill in with ink.

Fine-tip pen

A fine-tip pen is used for most of the alphabets in this book. Because you are drawing your letters, rather than writing them, you can use your fine-tip pen to make them as wide or as narrow as you wish. It is also great for outlining letters or creating delicate ornamental details.

Chisel-tip pen

This pen is great for broad and fine strokes, which, when used together, can create some lovely blackletters.

Brush pen

Mostly used for creating lovely brush scripts.

PENCILS

I love the feel of pencil on paper, and they're great to sketch and experiment with. You might also use pencils to draw your letters before inking them in. The choice between wooden and mechanical is down to personal preference.

Wooden pencil

With a wooden pencil you can achieve a varied line width depending on the pressure you apply.

Mechanical pencil

This is much more suited for precise and uniform lines without having to sharpen. Great for very technical and tight letters.

Eraser

White erasers tend to not leave streaks and remove mistakes more cleanly.

PAPER

When you are planning your designs, smooth paper is the best choice for ease of drawing with pencils or pens. White printer paper is perfect for this.

RULER

This is obviously essential for creating straight lines for base-, mid-, and cap line guidelines, and margins.

TRACING PAPER

Lay this semi-transparent paper over current sketches to make revisions, and continue the process with new sheets until you're satisfied.

PAINTBRUSHES

These are great when you're looking for something less precise, but more expressive, than pens. Round or flat brushes are ideal and provide different types of lines.

PEN NIB AND NIB HOLDER

Used for traditional calligraphy, a pen nib and holder, like a brush pen, renders beautiful scripts.

INK WELL

Used for dipping your nib into ink when using a pen nib and holder.

COMPASS

Perfect for drawing consistent curved lines or circles for layouts.

EXPERIMENT

Breaking away from using the expected tools for hand lettering can be a lot of fun. To keep things interesting when it comes to surfaces and mediums, I love to try something new. Playing in different scales, especially in larger formats, is great, too. Each variable brings a new challenge, but with practice, you can really render some beautiful results.

So, if you find yourself in need of inspiration, look around you, and you might find something that could serve as a new hand-lettering tool or surface to create a piece for. There aren't any rules!

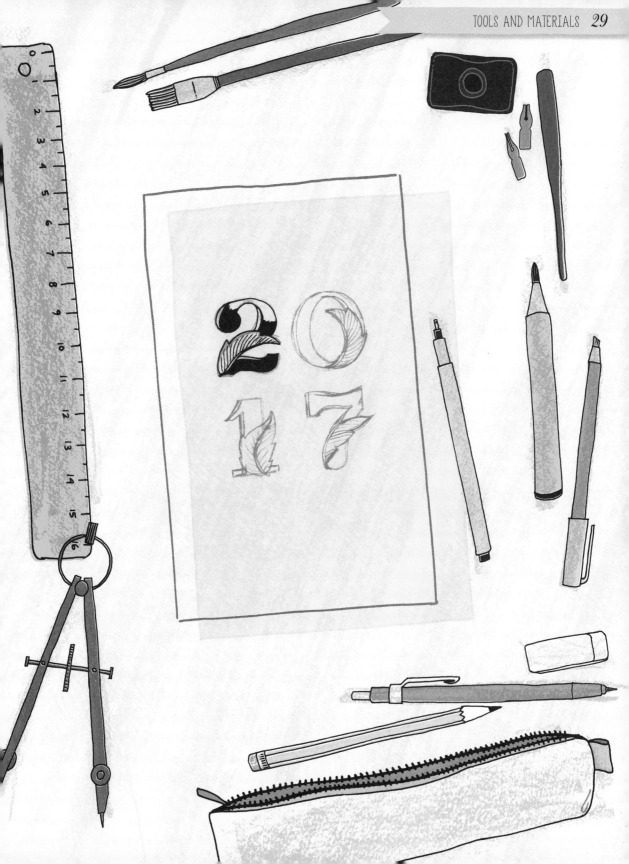

ANATOMY OF LETTERING

Rather than being vague or incorrect about how we describe parts of the letters we're about to construct, why don't we all get on the same page of what's what? I mean, at least now you'll know what you can call that curvy shape on the lowercase "r." Read up and take note!

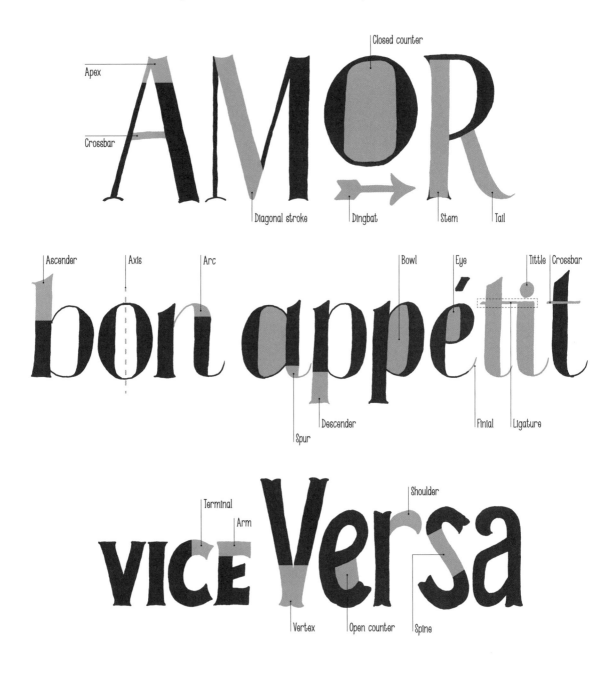

SERIF AND SANS SERIF

A serif is a line or embellishment that extends from the stroke of a letter. If a letter is sans serif, therefore, it does not have a line or embellishment attached to it. There are plenty of varieties of serifs.

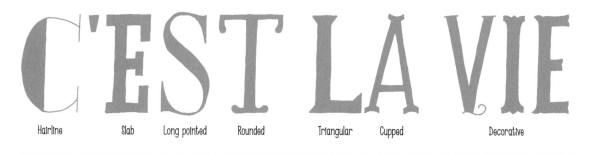

| Hairline | Slab | Long pointed | Rounded | Triangular | Cupped | Decorative |

WEIGHTS

Mono-weight refers to a single width throughout the letter, so your vertical and horizontal lines all have the same single weight. Altering the weight of a letter can change the emphasis of the letter itself. You can add weight simply by thickening all of the lines within the letter, or you can opt for playing around with the width of your lettering by condensing it. Here are some fun examples.

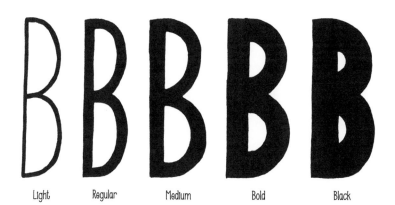

| Light | Regular | Medium | Bold | Black |

High contrast
Here there are extreme changes in weight through the letter. Notice the very heavy vertical strokes, versus the thin horizontal strokes. This contrast can be as great as you want to make it.

Medium contrast
Here the contrast between thicks and thins is less extreme than that of a high-contrast letter.

Low contrast
There is very little difference in the thick to thins here, where they only slightly contrast.

GUIDELINES

All letters vary in their proportion of width to height, and letters within the same alphabet will vary too. The styles that you read in a book or magazine will likely be "standard" or "normal." Styles that are narrower would be called "condensed," and styles that are wider are "extended."

When establishing standard or normal proportions, there are some helpful rules, shown right.

O has equal width to its height
M is wider than its height, this also applies to W
V is three quarters of its height
E is half of its height

See below for other rules that will help govern proportion in your alphabet.

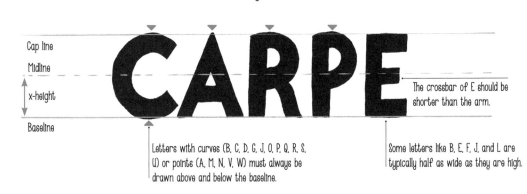

Cap line
Midline
x-height
Baseline

The crossbar of E should be shorter than the arm.

Letters with curves (B, C, D, G, J, O, P, Q, R, S, U) or points (A, M, N, V, W) must always be drawn above and below the baseline.

Some letters like B, E, F, J, and L are typically half as wide as they are high.

DRAWING GUIDES

Guidelines are a good way to keep track of how you're establishing your letters. It will ensure you have consistent lines of reference as each letter is developed. Start by choosing an easy measurement to use as an increment for your guidelines. Create tick marks along one side of a sheet of white printer paper. Repeat the same along the opposite side, being sure to start at the same place on the opposite edge. Use your ruler to draw a line to connect each tick mark directly across from it. Each set of three lines will define your cap line, midline (marking the x-height), and baseline. I use a dashed line for the midline so I clearly know where it is. The fourth line down will be the cap line for the next set of three guidelines.

Slant guidelines

The alphabets Penelope, Newfangled, Icing, and Ferry make use of slanted guidelines. Draw a slanted line perpendicular to your initial horizontal guidelines. Your first slanted guideline can be as angled as you like: the more slanted it is, the more italic your letters will be. Starting where the slanted guideline intersects with the cap line, make tick marks along the cap line in equal increments. Repeat the same along the baseline, starting where the slant guideline intersects with the baseline. Then, using your ruler, draw a line to connect each set of tick marks.

To ensure consistent letterforms, use these slanted guidelines to inform stems of letters and connecting arcs or closing bowls. It may take some practice, but these extra vertical guidelines will be a great help.

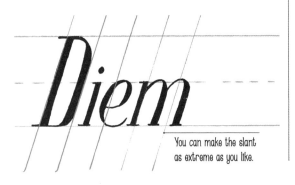

You can make the slant as extreme as you like.

LETTER SPACING

The relationship between letterforms is very important. If the letters are too close together, they will look cluttered, whereas if they are too far apart, the relationship between them is lost. You can have any kind of spacing you prefer, whether it be loose or tight spacing. Like determining proportions, it's a visual balance.

Tracing paper is really helpful for addressing letter spacing issues while also building your letters. Say you've drawn the skeleton of the letters in your word but the last two letters have too much space between them compared to the rest. In your second stage of adding weight, you can draw out the first letters but before you draw the last letter, lift your tracing paper and position the letter to where it feels more evenly spaced and continue the refinement step. You can do this at any point along the process so that it's just right at the end.

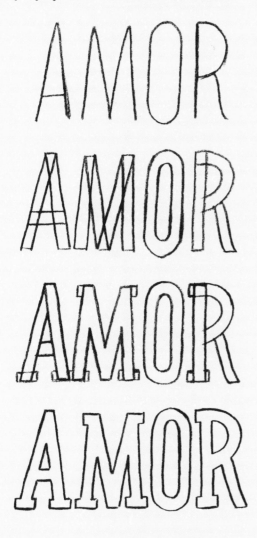

1 Basic shape
To start your letter spacing, it's easiest to draw a skeleton of the general shape you're trying to achieve. You can build on this as you decide what style you plan to execute.

2 Adding weight
Here, I've decided on a mono-weight style, so I've maintained an even width in my letters throughout.

3 Including serifs
I've added a slab serif and now have a general wireframe to outline in the next round. However, I can also now see that my "A" and "M" feel too close together. This is where the tracing paper comes in...

4 Tracing and neatening
Use tracing paper to cleanly redraw the letters and make necessary adjustments to the letters and their spacing. Lay a sheet of tracing paper over your work. Use masking tape to adhere the tracing paper to the original so it doesn't move. Taking your time, redraw your letters. Having your letters solved as much as possible when it comes to widths, curves, spacing, etc, makes it much easier when you move on to the inking stage (see page 40).

LAYOUT

An effective way to give your completed piece interest is by experimenting with layout. As you get more creative with your layouts you'll see more dynamic results, so it's best to experiment with several possibilities before choosing a direction to go with. Thumbnail sketching is a great way to brainstorm layout ideas.

KEEP IT CLEAR

When you are planning a layout for a simple sign, remember that, for readability and impact, a simple layout is best. The rule of less is more works well here so as not to interfere with the beautiful, but clear message.

WORKING IN LARGE SCALE

Layouts for posters can be more complex, but should still be simple enough that the reader can easily access the message. Using a curved baseline and stacking the letters vertically creates a more interesting layout that is still readable.

ASYMMETRICAL COMPOSITION

Another easy way to add interest to a layout is to use off-center alignments for a more asymmetrical composition. Here, the combination of a straight baseline, a slanted baseline, and a right-aligned word creates a dynamic piece for even the most simple of posters.

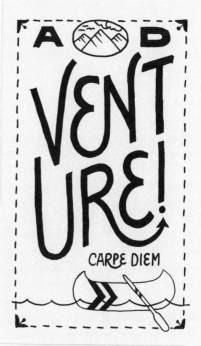

QUICK TIPS

- **Do**: Think about how many words are being used in the overall piece. Sketching placeholder shapes ensures you won't run out of space.
- **Don't**: Forget about margins! Unless you want the piece to go off the edge, consider how much space you want around your lettering and plan it into your sketch.

FITTING LOTS OF INFORMATION

Having a plan for a layout is especially helpful when organizing a lot of information. Without a thought-through layout, a piece can quickly appear scattered and messy. Here, a slanted baseline is used in combination with straight and curved baselines to section out the items of information.

It's important to note that your information should be considered when deciding which portions are grouped together. For example, I isolated Émilie's name because she's the focal point of this invitation, whereas the request for a response is played down since it's more of a tertiary element in the hierarchy of information.

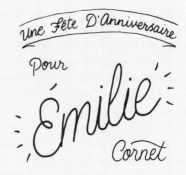

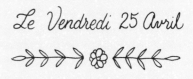

COMBINING STYLES OF LETTERING

Using different lettering styles for one piece of work can render some lovely results. However, as with all aspects of lettering, be careful not to go overboard with complexity. Combining too many styles can be a fast path to chaos, and make a piece feel cluttered and difficult to read.

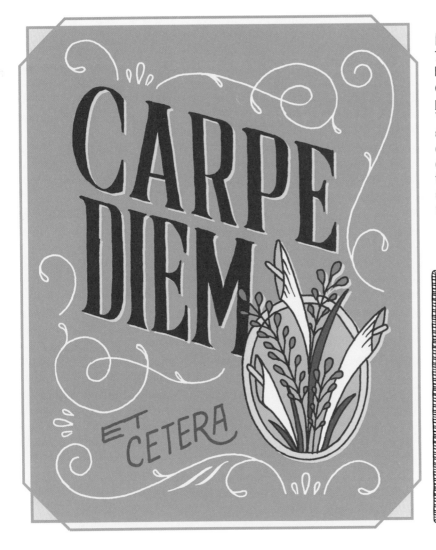

MIXING CHARACTERISTICS

These two styles combine well because they create a nice contrast that is used to punctuate the primary words. You can always spice up sans-serif styles with a mix of characteristics from serif or script styles, like a swash (on the "R" in "cetera"). It makes the style a little more unique and interesting.

QUICK TIPS

- **Do:** Consider your content and what you want to highlight or where you're creating contrast. It will help how it reads.
- **Don't:** Combine too many styles and keep the change in styles to words or groups of words. Changing styles within a word may result in the piece feeling jumpy or messy.

VARIATION WITHIN A STYLE

Decorative and fun styles can easily be combined with a simple, handwritten sans-serif style. To create more variety, you can even use condensed and wider variations of the same style.

CLEVER CONTRASTING

The combining of styles doesn't need to be complicated or complex to create interest, or a more compelling piece. Since scripts are already expressive, it's important to contrast while not overdoing it. I chose a simple sans-serif style for "La" to contrast with, but not outshine, the beautiful script.

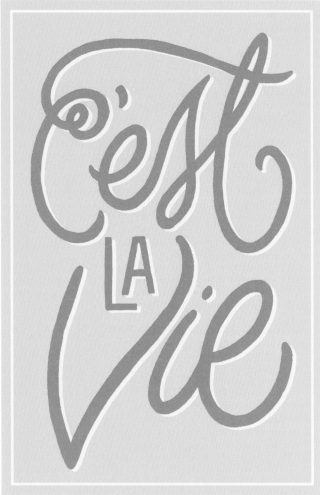

EMBELLISHING

Embellishing is an easy and fun way to give your letters a little more life. This can be achieved by adding shading, ornaments, filigree, inlines, outlines, and more!

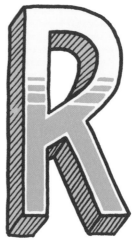

SHADING

One of the easiest ways to embellish a letter is to add shading. You can shade within the letter, to show some dimension or interest, or create drop shadows for a more dynamic look. Here, I've illustrated a few examples with shading and drop shadows to give you some idea of what you could experiment with.

Shading within

Using shading within a letter can create wonderful visual impact. Here, I've used a simplified shading with shapes as well as shading within the extruded parts to create more depth.

Stippling

Stippling is a great shading technique. Keep in mind where on the letter you want the highlights to be: the dot shading method will be the least dense in the highlights and the most dense in the shadows. Using a fine-tip pen, start with dots that are close together in the shadow areas, then become sparse as you get to your highlight areas. It may take a few passes to get the density right, but aim for a gradual transition from sparse to dense. Take your time and you'll get some beautiful results.

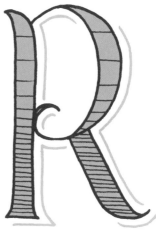

Linear

You can take an entirely linear approach to your shading and drop shadows. This is a more textural approach, with less drama than solid shading, but still adds interest.

FILIGREE, INLINE, AND OUTLINE

This trio is another set of easy and beautiful embellishments that can liven up your letterforms.
Each can be simple or complex in how you execute them, but all will add character.

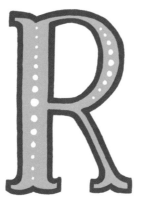

Filigree
When adding delicate filigree motifs it is easy to get carried away. Make sure you allow for space and balance to ensure the decoration does not feel messy.

Inline
An inline-drawn inside parts of the letter-can be simple or more decoratively complex, depending on the shape or shapes you choose to use.

Outlines
An outline surrounds the letter and adds some fun. You can even double up or use a dashed or dotted line for more possibilities.

OTHER DECORATIVE EMBELLISHMENTS

As you continue to experiment with embellishing letters, you'll find that the possibilities are nearly endless. Try flowers, lines, patterns, or anything else you can dream up. Keep balance in mind and the need for some "air," to ensure that you don't overembellish and end up with a mess.

Florals
Florals can quickly add beauty to your letterforms, but don't let them overpower the design.

Texture
Lines can be used for shading within the letter and as drop shadows, for added texture.

Motifs
Motifs, such as florals, geometrics, or animals, can be placed within a letter for ornamentation.

INKING AND COLORING

This stage is the most fun, as you get to see your work come to life. Take your time and bear in mind that you might have to do it again, but don't get frustrated. If you plan to color your work by hand, do steps 1 through 2. This will give you crisp lines to trace and transfer to another medium. If you plan to digitize your work and color it on the computer, follow steps 1 to 4.

INKING

The inking stage happens when you have arranged and are happy with all the elements of your final layout. It is especially important if you are preparing to scan your artwork to digitize it, since a black-and-white image makes things easier when cleaning up your files. There is no one perfect way of inking, but here is what I typically do. Feel free to adapt your own method and don't worry about making mistakes, that's how you'll find what works best for you.

However you decide to ink, always be sure to take your time. This isn't a stage you want to rush, since this can quickly result in errors that can't be fixed.

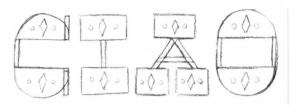

1 TRACE YOUR SKETCH
When you are happy with your layout, lay tracing paper over your drawing. At this stage I don't tape the tracing paper to the surface of my desk or table because I like to be able to rotate it. You'll see why below.

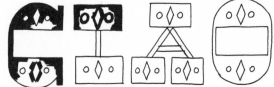

3 FILLING IN
Start with any letter you like and use short line strokes to fill it in. Control is still important if you don't want to accidentally draw out of the lines. Having your paper not taped to the surface means you can freely rotate as you fill. Another method is filling with a circular motion. I've started the "I" with this method, working inward from the outlines. Do what feels natural to you.

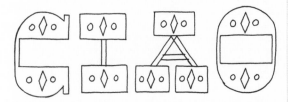

2 DRAW TOWARD YOURSELF
Drawing on your tracing paper, use a fine-tip pen to outline. I keep my intersecting lines perpendicular to ensure I get a continuous line instead of accidentally stopping short and making the line bubble when I try to complete it. Draw toward yourself and try not to draw long lines, since you may find that your line control becomes lost. Rotate the page as needed.

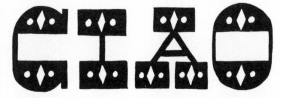

4 STEP BACK
Your final product should look evenly filled in. It's a good idea to take a step back and correct any strokes or shapes. Be careful when fixing any problems, since it is easy to get carried away and end up having to redo a letter. Take your time.

COLORING BY HAND

If you work directly onto the final paper source, you may need to use a lightbox in order to see through the paper to your layout drawing. Place the drawing on the lightbox and tape the paper over it, positioning the letters where you want them on the paper. Using a pencil, lightly trace your letters onto the paper, drawing toward you. To keep good line quality, don't draw in the lines that intersect one another. For example, if you don't want your "A" to look like three horizontal rectangles with stems that intersect, only draw the outlines of the letterforms. Then color in as you wish.

I find it easy to color with colored pencils or watercolor, especially when I'm creating a card or fun note. I encourage you to try different media however, as there are no rules of what you can and cannot use.

PREPARING TO COLOR DIGITALLY

While there are plenty of methods to color your lettering, the digital medium is probably the most common. Typically, I get my artwork to semi-inked stage, which is what you get after step 1 to 4 from the previous page. Scan your work into the computer at 600dpi or higher. Then open the scanned image in Photoshop to increase the contrast and clean up any undesired lines, spots, or lint.

To digitize the lettering, open the cleaned up file in Illustrator and navigate to the Live Tracing menu. Under Tracing Options, adjust the threshold and path fitting settings while also toggling Preview so you can see what the result will be. To retain the integrity of the hand drawn look, use a higher threshold and a low path fitting. After the live trace has rendered, click Expand. Now the image is vectorized and ready for coloring.

Colored pencil

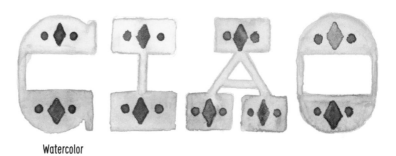

Watercolor

Digital

QUICK TIPS

- **Do:** Start with your smallest fine-tip pen to outline or ink. You can always increase your line thickness for filling in if it seems like there isn't too much detail you might mess up.

- **Don't:** Rush. This isn't a fast process so be patient and don't consume too much coffee or sugar before—you need a steady hand.

DIRECTORY OF ALPHABETS

1 Boulangerie

Evoking the sweet smell of pastries and delicious baked goods, "Boulangerie" lettering has charming qualities that are sure to delight on any storefront sign or brunch invitation.

CAPITAL CONSTRUCTION

Using a fine-tip pen, draw the stem of your letter.

Draw the bowl and continue into a loop. Continue from the loop to draw the tail.

Add tiny teardrop-like terminals (known as lachrymal terminals).

A B C D E F G

H I J K L M

N O P Q R S

T U V W X

Y Z ! ? &

1 2 3 4 5

TOOL

• Fine-tip pen

LOWERCASE CONSTRUCTION

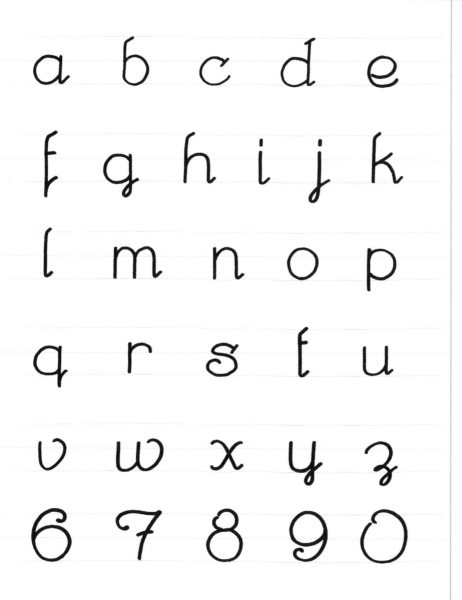

Using a fine-tip pen, draw the stem of your letter.

Starting just below halfway down the stem, draw the shoulder into the stem.

Draw a spur to complete the letter.

2 Metal Head

While "Metal Head" may not be as hardcore as they come, it still packs some "rock" attitude when you need it. Use it on your next gig poster and this alphabet is sure to inspire some serious head-bangin'.

CAPITAL CONSTRUCTION

Using a chisel-tip pen and angling the tip at 45 degrees, draw the stem.

Starting at the top of the stem, draw a diamond to the right and then pull down from there to complete the bowl.

To draw the tail, start with a diamond about halfway down the right side of the stem, then pull down to complete.

A B C D E F G

H I J K L M N

O P Q R S T U

V W X Y Z ! ?

& 1 2 3 4 5 6

7 8 9 0

a b c d e f

g h i j k l

m n o p q

r s t u v

w x y z

LOWERCASE CONSTRUCTION

Using a chisel-tip pen and angling the tip at 45 degrees, draw the stem.

Starting at the top of the stem, draw a diamond to the right.

Pull down from the diamond and stop at the point you want to return to the stem.

3 Penelope

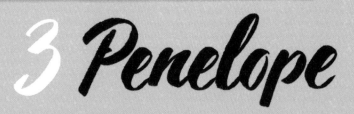

"Penelope" is the sweet girl next door who loves to write notes to her friends and loved ones. This quick and casual script has a kind, inviting tone that makes it perfect for a friendly "hello."

CAPITAL CONSTRUCTION

Start just below the cap line. Using the slanted lines as guides, draw upward and apply more pressure as you pull down. Ease up when you draw up again.

Next, start just above the midline, and repeat the first curve.

Finish by drawing a curved stroke upward.

A B C D E F
G H I J K L
M N O P Q R
S T U V W
X Y Z ! ? &
1 2 3 4 5

TOOL

- Brush pen

a b c d e

f g h i j

k l m n o

p q r s t

u v w x y z

6 7 8 9 0

LOWERCASE CONSTRUCTION

With the brush pen, draw a lowercase "c" at the same angle as your slanted lines.

Continue upward to complete the finial.

Start at the top and complete the letter to create the eye.

4 *Vinyl Love*

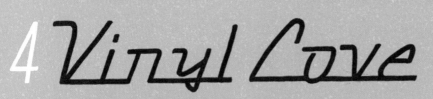

"Vinyl Love" is all about high fidelity, and would appeal to record collectors everywhere. This alphabet is perfect for a store or bar sign, with a nod to the retro nature of all things analog.

CAPITAL CONSTRUCTION

Using a chisel-tip pen, draw the stem of your letter. In order to maintain a mono-weight line, keep the tip perpendicular to the direction you're pulling in.

Draw the other stem, pulling down and maintaining the mono-weight line.

Starting at the base of the stems, draw a continuing line that will connect to the next letter.

A B C D E F
G H I J K L
M N O P Q
R S T U V
W X Y Z ! ?
& 1 2 3 4 5

TOOL

• Chisel-tip pen

a b c d e f

g h i j k

l m n o p

q r s t u

v w x y z

6 7 8 9 0

LOWERCASE CONSTRUCTION

Starting at the midline, use a chisel-tip pen to draw the stem of your letter. In order to maintain a mono-weight line, keep the tip perpendicular to the direction you're pulling in.

Draw the other stem, pulling down and maintaining the mono-weight line.

Starting at the base of the stems, draw a continuing line that will connect to the next letter.

5 Leona

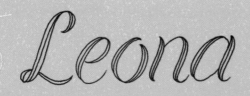

Truth be told, "Leona" is named after my sister, who carries beauty in the way she lives organically and flows with life, but also knows how to stay centered and balanced. This alphabet is intended to be beautiful, but functional, for greeting cards or a quick, kind note.

CAPITAL CONSTRUCTION

Using a fine-tip pen, draw the stem of your letter with tapered ends.

Draw in the top and bottom bowls with ends that taper when approaching the cap, mid-, and baseline.

Add a serif at the top.

Finish by drawing inlines the entire length of the stem, bowls, and serif.

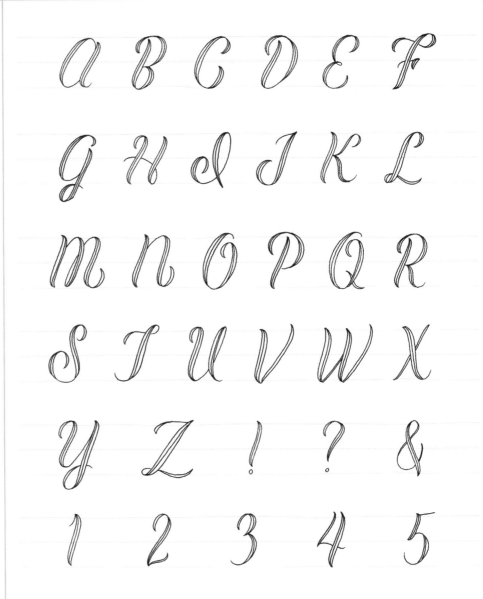

TOOL

• Fine-tip pen

LOWERCASE CONSTRUCTION

a b c d e f

g h i j k

l m n o p

q r s t u

v w x y z

6 7 8 9 0

Using a fine-tip pen, draw the stem of your letter with tapered ends.

Draw in the bowl with ends that taper when approaching the mid- and baseline.

Finish by drawing inlines the entire length of the stem and the bowl.

6 *Marilyn*

"Marilyn" is inspired by the late Marilyn Monroe, whose beauty enchanted everyone. This script is bold, delicate, and charms you with sweetness: perfect for wedding invitations or "thank-you" cards.

CAPITAL CONSTRUCTION

Using a brush pen, draw the stem of your letter, applying more pressure as you pull down but lifting as you go up to create your thicks and thins.

Start around the midline and pull across and down to create the crossbar that will connect to the bottom of the left stem.

Complete the letter by pulling a thin line down to create the left stem.

$$\mathcal{A} \quad \mathcal{B} \quad \mathcal{C} \quad \mathcal{D} \quad \mathcal{E} \quad \mathcal{F}$$

$$\mathcal{G} \quad \mathcal{H} \quad \mathcal{I} \quad \mathcal{J} \quad \mathcal{K} \quad \mathcal{L}$$

$$\mathcal{M} \quad \mathcal{N} \quad \mathcal{O} \quad \mathcal{P} \quad \mathcal{Q}$$

$$\mathcal{R} \quad \mathcal{T} \quad \mathcal{U} \quad \mathcal{V} \quad \mathcal{W}$$

$$\mathcal{X} \quad \mathcal{Y} \quad \mathcal{Z} \quad ! \quad ? \quad \&$$

$$1 \quad 2 \quad 3 \quad 4 \quad 5$$

a b c d e f

g h i j k l

m n o p q

r s t u v

w x y z

6 7 8 9 0

TOOL

• Brush pen

LOWERCASE CONSTRUCTION

Using a brush pen, start at the midline. Pull up and then down to create the start of the bowl. Add pressure as you pull down to create a thicker line, and lift at the end to taper.

Finish the bowl with a light upstroke that stops halfway between the mid- and baseline.

Complete the letter by drawing the stem. Again, apply more pressure as you pull your downstroke and lift as you come up.

7 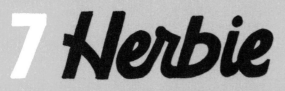 Herbie

"Herbie" the Love Bug is clearly the inspiration behind this fun alphabet, which nods to the late-1960s' film. This alphabet is just as fun and quirky as the original VW Beetle, and would work wonderfully painted on a car or a race-day poster.

CAPITAL CONSTRUCTION

Starting halfway between the cap line and midline, use a fine-tip pen to draw the stem of your letter.

Draw in the top bowl. Make sure you maintain the same weight throughout the letter.

Finish by completing the bottom bowl.

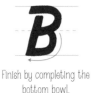

A B C D E F
G H I J K L
M N O P Q R
S T U V W
X Y Z ! ? &
1 2 3 4 5

TOOL

- Fine-tip pen

LOWERCASE CONSTRUCTION

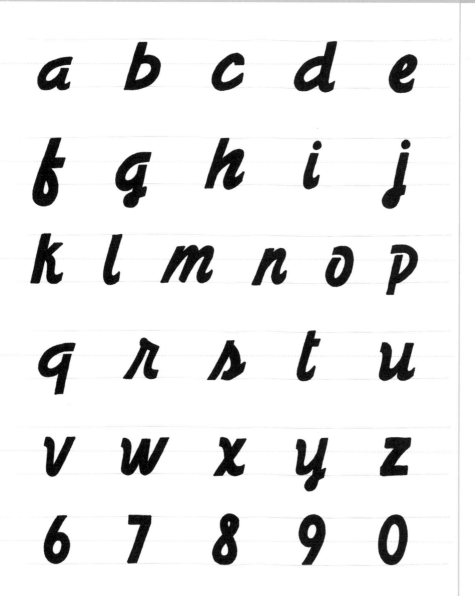

Starting just below the cap line, use a fine-tip pen to draw the stem of your letter.

Draw in the top of the bowl. Make sure you maintain the same weight through the letter.

Finish by completing the bottom of the bowl.

8 SPACE

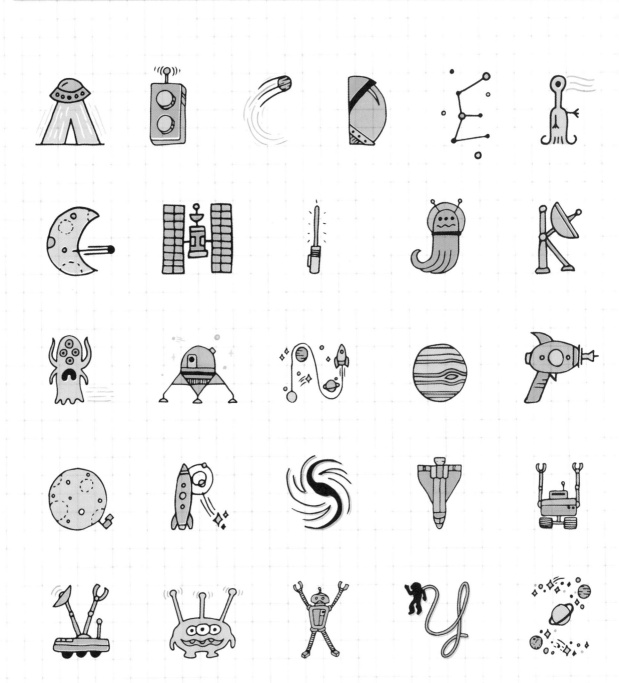

YOUR TURN

Americana

"Americana" is a stencil-style alphabet inspired by American-made brands and products. It's perfect for your next packaging project, label, or painted sign.

CAPITAL CONSTRUCTION

Using a fine-tip pen, create the stem with a taper to the start and finish.

Draw in the arm and leg. Again, create them with a taper at the start and finish. Be sure that they don't touch the stem.

Add decorative finishes to the tail, stem, and arm, again, making sure they don't touch the rest of the letter.

A B C D E F

G H I J K L

M N O P Q R

S T U V W

X Y Z ! ? &

1 2 3 4 5

TOOL

• Fine-tip pen

LOWERCASE CONSTRUCTION

Using a fine-tip pen, create the stem with a taper to the start and finish.

a b c d e

f g h i j

k l m n o

Draw in the arm and leg. Again, create them with a taper at the start and finish. Make sure they don't touch the stem.

p q r s t

u v w x y z

Add decorative finishes to the tail and stem, again, making sure they don't touch the rest of the letter.

6 7 8 9 0

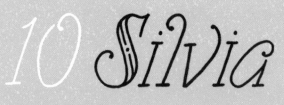

10 Silvia

"Silvia" is a lady who loves a touch of the unique and beautiful, while still keeping it simple. This alphabet is perfect for an invitation or announcement that needs a sweet, feminine touch.

CAPITAL CONSTRUCTION

Using a fine-tip pen, draw each side of the "O." Notice the small notch at the top.

Parallel to the left side, echo another line inside the left side of the bowl.

Add a line that splits the left side, being careful to leave a space. To complete, add a simple dot.

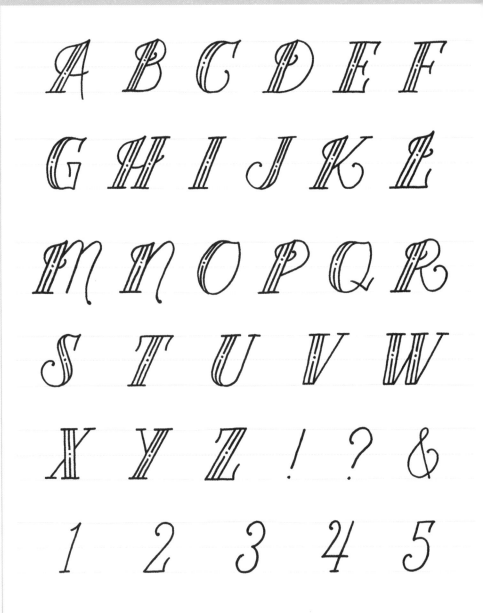

TOOL

- Fine-tip pen

a b c d e

f g h i j

k l m n o

p q r s t

u v w x y z

6 7 8 9 0

LOWERCASE CONSTRUCTION

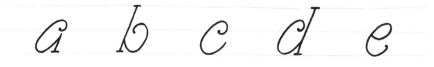

Using a fine-tip pen, start the top of the letter just above the midline.

Draw in the right side of the bowl.

To complete, draw the left side of the letter, starting just below the midline.

TOOLS

- Pencil
- Fine-tip pen

11 ASGARD

A simplified and modern take on an ancient Nordic theme, "Asgard" is perfect for a winter-themed wedding menu, or a comic featuring heroes like Thor or Odin.

BASIC CONSTRUCTION

Using a pencil, sketch the three strokes of the 'W,' making sure they have even weight.

Now sketch in the two vertexes. Again, try to keep them of even weight.

Finish the sketch by adding tops to the strokes.

Use a fine-tip pen to ink in the letter.

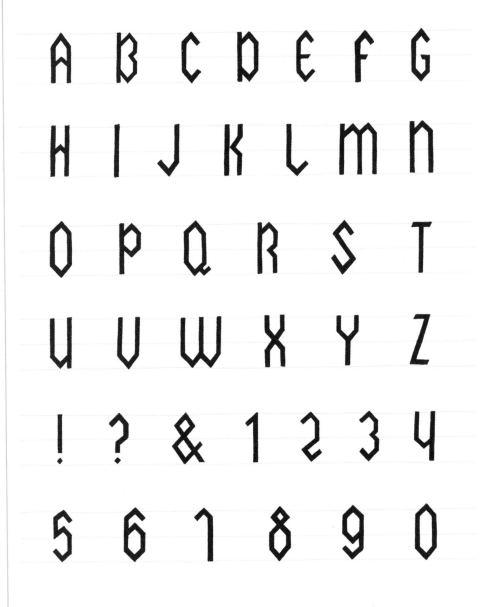

12 HELLO FROM...

"Hello From..." is inspired by the fun tile lettering you find in entryways to coffee shops and buildings, or even inside bathrooms and kitchens. This quirky, modular alphabet can be used for gig posters or party invites.

TOOL

• Fine-tip pen

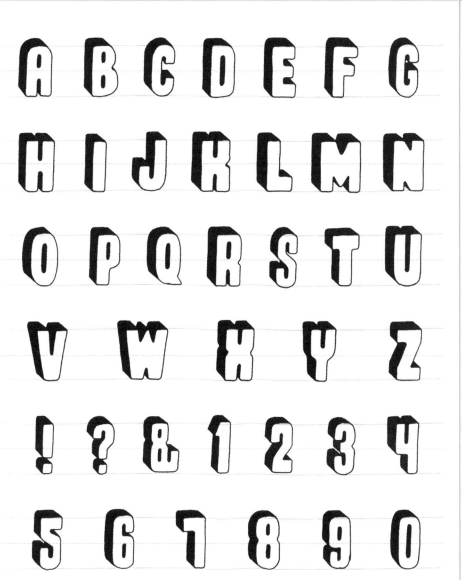

BASIC CONSTRUCTION

Use a fine-tip pen to draw the letter in block form. The basic shape.

Round all of the corners.

Add depth to your letter. Be sure to keep your angled lines parallel to each other, and your vertical lines parallel to the sides of the letter.

Use the pen to ink in the shadow.

TOOLS
- Pencil
- Fine-tip pen

13 GEORGE

"George" has a bold yet understated style. He could easily be a blue-collar kind of guy, but carries himself proudly. Any signage or doodle for your new journal would be fitting for this alphabet.

BASIC CONSTRUCTION

Using a pencil, draw the basic shape of the letter.

Add on some simple serifs for some understated style.

Create a simple, decorative element with an outline.

Complete the letter by inking it with a fine-tip pen.

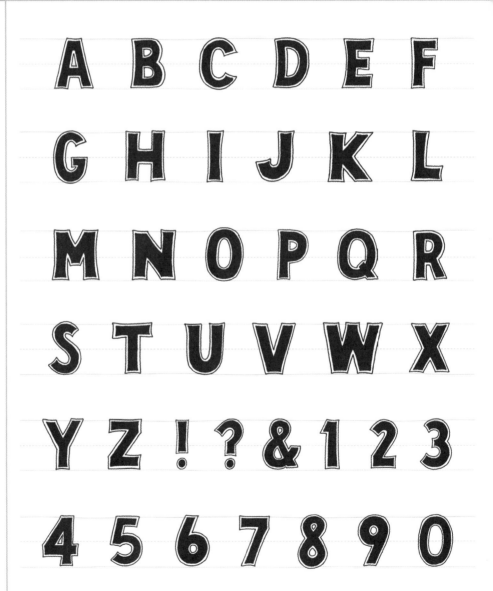

A B C D E F
G H I J K L
M N O P Q R
S T U V W X
Y Z ! ? & 1 2 3
4 5 6 7 8 9 0

HAPPY!

M

14 Bel Air

"Bel Air" is reminiscent of a cool and carefree breeze, the kind that kisses your skin while enjoying a California sunset. This alphabet is perfect for a poster or a casual sign for your next summertime get-together.

CAPITAL CONSTRUCTION

Using a fine-tip pen, draw the skeleton of your letter.

Draw the strokes of the letter, tapering as you get to the bottom so that the letter finishes in a fine stroke.

Use the pen to fill in the downstrokes of the letter and go back over the fine strokes.

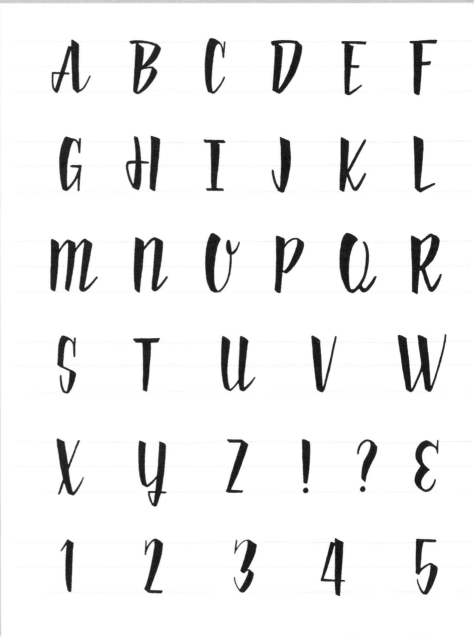

TOOL

• Fine-tip pen

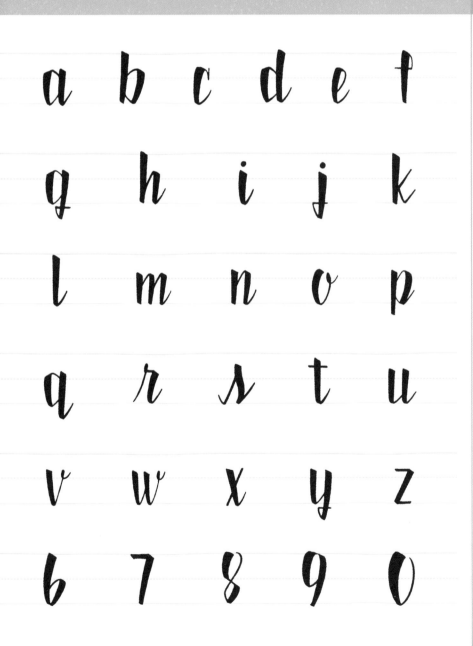

LOWERCASE CONSTRUCTION

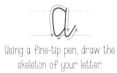

Using a fine-tip pen, draw the skeleton of your letter.

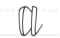

Draw the strokes of the letter, tapering as you get to the bottom so that the letter finishes in a fine stroke.

Use the pen to fill in the downstrokes of the letter and go back over the fine strokes.

15 Caroline

Kind, sweet "Caroline" loves daisies and frolicking in the hills with springtime flowers. She'll be a sure win for any casual "hello" note to a friend, or cute labels for your garden.

CAPITAL CONSTRUCTION

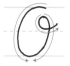

Using a fine-tip pen, draw the skeleton of your letter.

Add more weight to your letter, but keep an even mono-weight line.

Use the pen to fill in the letter.

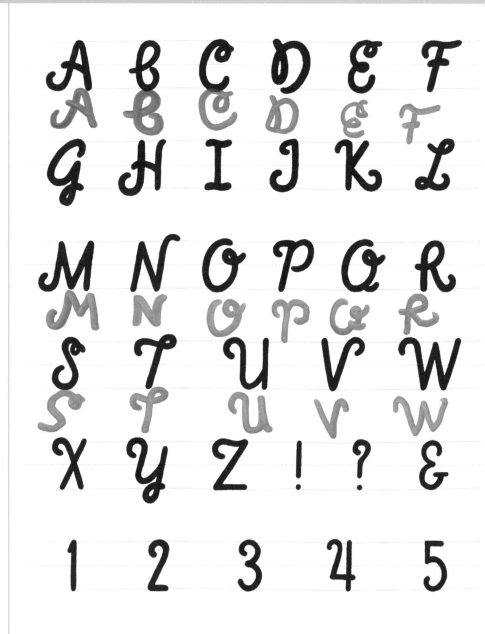

TOOL

• Fine-tip pen

LOWERCASE CONSTRUCTION

Using a fine-tip pen, draw the skeleton of your letter.

Add more weight to your letter, but keep an even mono-weight line.

Use the pen to fill in the letter.

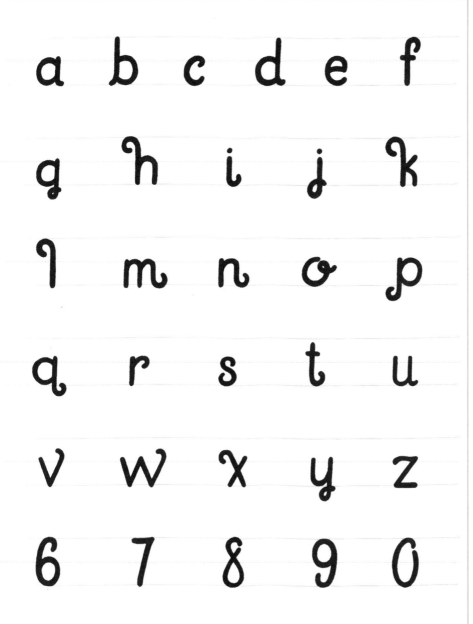

16 FANTASY CREATURES

by Amy Rogstad

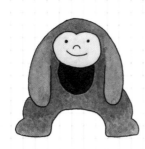
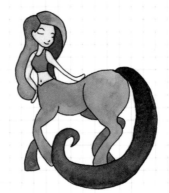

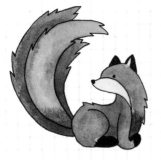

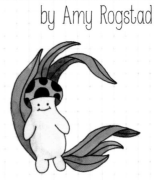

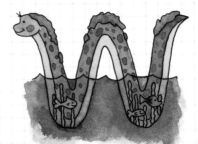

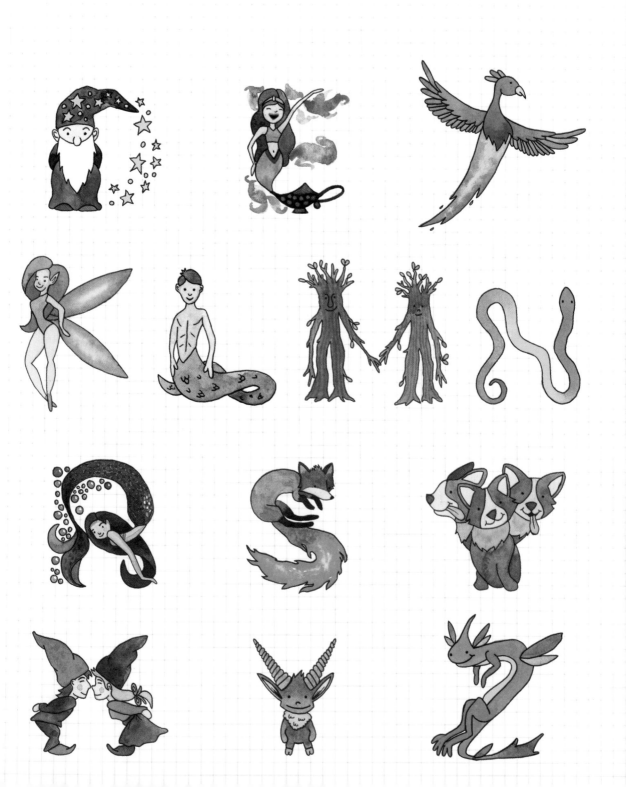

TOOL

• Fine-tip pen

17 PILLAR

This serif font style by Abbey Sy is a modern take on the Roman pillar.

BASIC CONSTRUCTION

Using a fine-tip pen, start by drawing a basic serif letterform.

Thicken the stem of the serif letter.

Color the lower part of the letter, leaving a 'V' shape at the top of the filled-in area.

Add an exclamation point in the center of the white part of the stem.

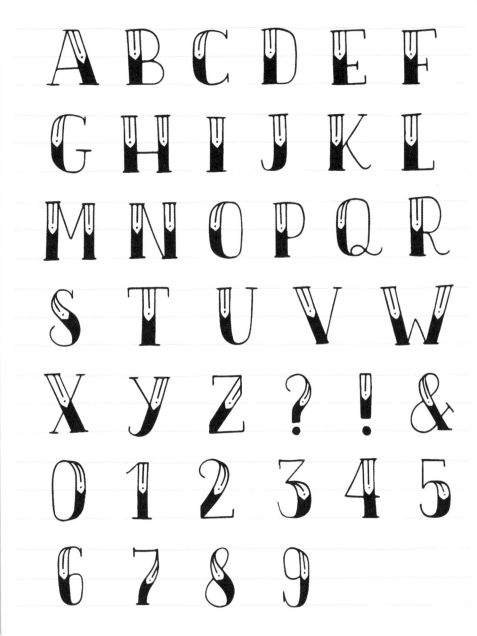

18 ROBOTYPE

Inspired by futuristic type, Abbey Sy's "Robotype" is a squarish block sans-serif font that pays homage to all things innovative.

TOOL

• Fine-tip pen

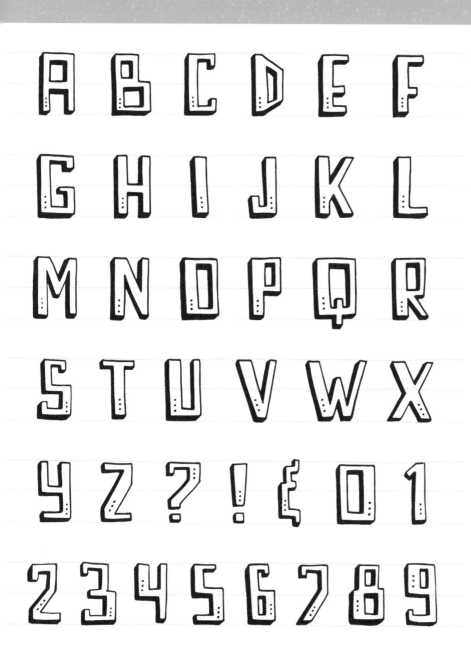

BASIC CONSTRUCTION

Start with the square-type skeleton of the sans-serif letter.

Draw an outline connected to the skeleton to make a block letter. Note that one side of the letter is distinctively thicker than the others.

Add three dots at the bottom of the stem.

To achieve a 3D effect, finish it off with a shadow directing to the bottom left.

TOOL

- Chisel-tip pen

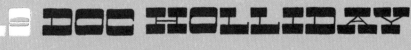

"Doc Holliday" is a good ol' Wild West gunfighting gambler with wit and a rather colorful life. This alphabet is sure to hit the bullseye in true Western style.

BASIC CONSTRUCTION

Draw the stems of the letter with the tip of a chisel-tip pen to create a thin line.

Add the crossbar.

Add some thick slab serifs to finish the letter.

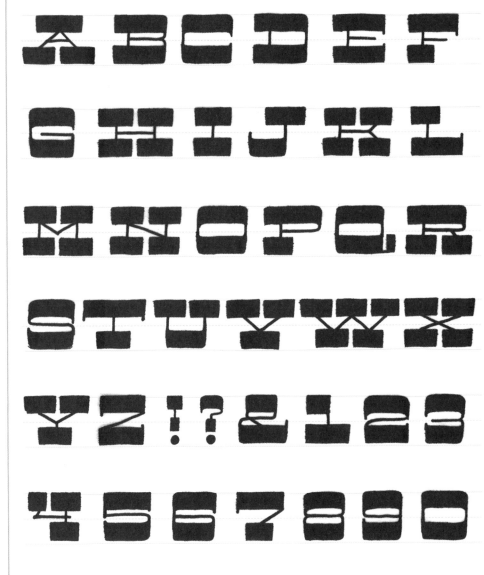

YOUR TURN

20 AUTOMOBILES
by Alexandra Snowdon

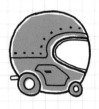
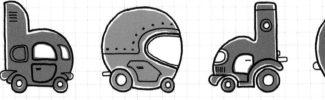
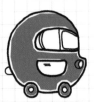
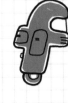

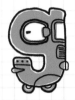
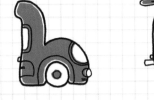
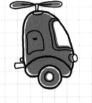
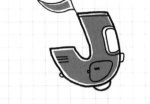
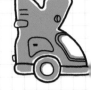

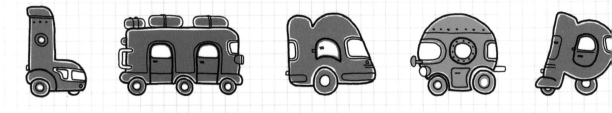

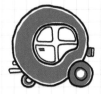
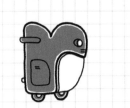
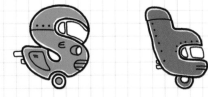

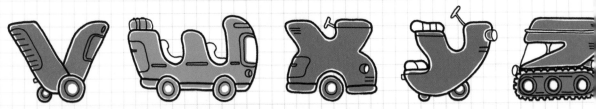

YOUR TURN

TOOL

- Brush pen

21 NEWFANGLED

Bringing back some old-school, casual sign-painting style, "Newfangled" is for those of us who crave a humanistic touch in this digital world. This alphabet is, obviously, perfect for signs or flyers.

BASIC CONSTRUCTION

Hold a brush pen at a 45-degree angle. Using the side of the brush rather than the point, draw a straight line parallel to the slanted lines.

Draw the first stroke of the top bowl. Use more pressure as you pull to create the light-to-heavy line.

Repeat to complete the uppermost bowl.

Repeat the previous two stages to complete the lower bowl.

A B C D E F
G H I J K L
M N O P Q R
S T U V W X
Y Z ! ? & 1 2
3 4 5 6 7 8 9 0

ABCDEFGH

A

S

TOOL

• Fine-tip pen

22 HABERDASHERY

A bold and handsome gentleman, "Haberdashery" is sure to make you look good. This alphabet's fine details and refined style could make anyone swoon.

BASIC CONSTRUCTION

Use a fine-tip pen to draw the basic shape, keeping the lines even throughout.

Add bracketed serifs.

Finish the letter with tiny hatching lines for shading, directing to the bottom right.

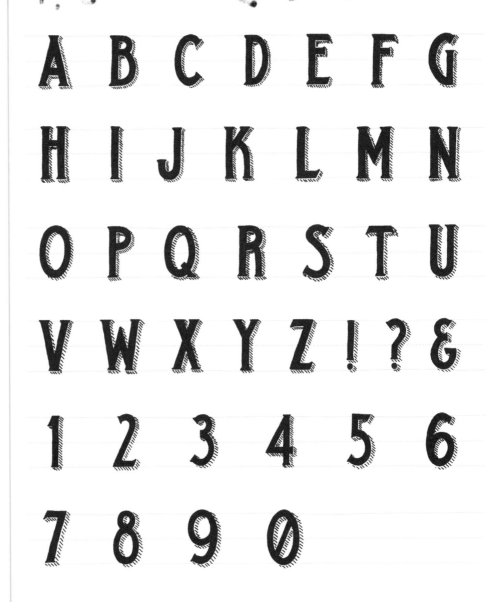

A B C D E F G
H I J K L M N
O P Q R S T U
V W X Y Z ! ? &
1 2 3 4 5 6
7 8 9 0

YOUR TURN

A B C D

H

TOOL

- Brush pen

"Inferno" is clearly too hot to handle. While this alphabet doesn't scream "I'm on fire," it will add great character to a design that's seeking mystery and horror of the devilish kind.

BASIC CONSTRUCTION

Use a brush pen to draw the stem, pressing harder on the downstroke to get a thicker line, then lifting toward the end to taper it.

Repeat with the second line, but start a little higher, slightly above the cap line.

Draw the crossbar at a slight angle.

A B C D E F G

H I J K L M N

O P Q R S T U

V W X Y Z ! ?

& 1 2 3 4 5 6

7 8 9 0

YOUR TURN

24 BUILDINGS

by Alexandra Snowdon

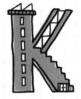

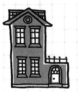

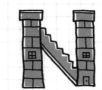

YOUR TURN

TOOL

• Fine-tip pen

BASIC CONSTRUCTION

Use a fine-tip pen to draw the top of the letter first. Add on the right side, keeping the width of the ribbon even.

Draw the left side of the letter, but don't finish to the baseline.

Draw the bottom shape and complete the left side where it meets the stem. Finish the right side.

Create a decorative crossbar to finish the letter.

25 RIBBON

"Ribbon" is obviously representational, but can be used for anything from festive announcements to crafty signs. It's intended to be fun but clean—for all of your ribbon needs.

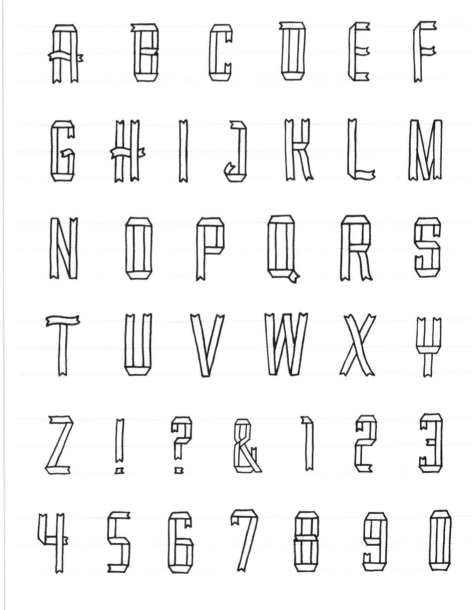

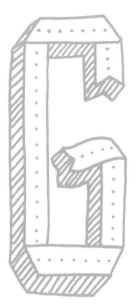

CREATING DIMENSION CAN
BE A FUN AND EASY WAY
TO LIVEN UP LETTERS.

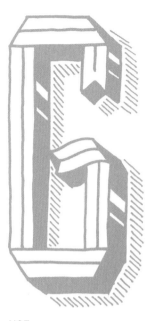

TRY your hand at a different perspective with blocking and hatched shading. Inlines can be solid, dashed, dots, or anything you like.

USE simple lines to imply depth and give more dimension to your letter. You can even layer a shadow onto another shadow.

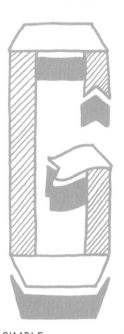

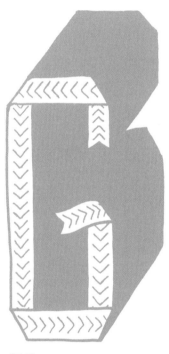

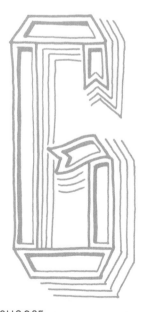

GIVE a more dramatic feel by using an extreme shadow that's solid. It really makes a statement. Also, echoing the direction of the ribbon with the shape I chose to use for my inline gives it more interesting depth.

SIMPLE lines go a long way. Using lines to imply shadows within the ribbon is a great way to give the ribbon itself some life.

CHOOSE where you want shadows to fall by increasing line weight. Here I've done this within the inline.

TOOL

• Fine-tip pen

26 ZOE

"Zoe" is a woman that makes a strong, stylish, and bold statement. She's inspired by art-deco lines and the flappers of the 1920s, who went against the grain for women. She'll add flair and style to any piece you couple her with.

BASIC CONSTRUCTION

Using a fine-tip pen, draw the top and left side.

Start just below the top crossbar, without connecting with it, and draw down, parallel to the stem. Finish with the bottom crossbar, making sure it's not longer than the top one.

Add the middle crossbar to finish the letter.

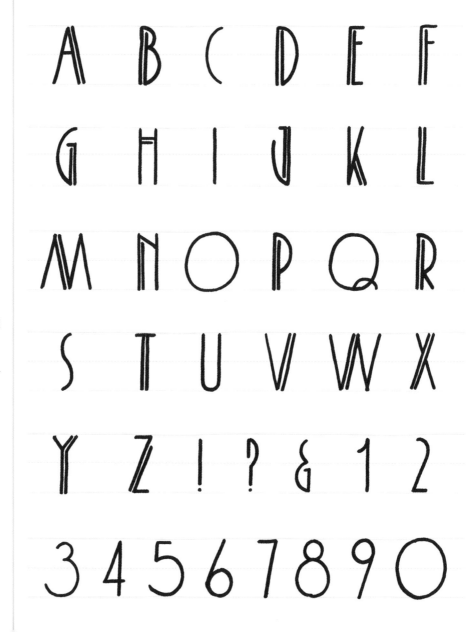

A B C D E F
G H I J K L
M N O P Q R
S T U V W X
Y Z ! ? & 1 2
3 4 5 6 7 8 9 0

YOUR TURN

A B C D E F

M

TOOLS

- Fine-tip pen
- Old paintbrush

27 BAD LUCK

"Bad Luck" is chock full of grit and bad news. With a nod to vintage B-movie posters from old Hollywood, this alphabet is great for those rough-and-rowdy moods.

BASIC CONSTRUCTION

Use a fine-tip pen to draw the basic shape, with a slight slant.

Use an old paintbrush and a dab of ink or paint to roughly draw the letter over the initial lines.

Build out with rough, dry strokes to achieve the desired width and weight.

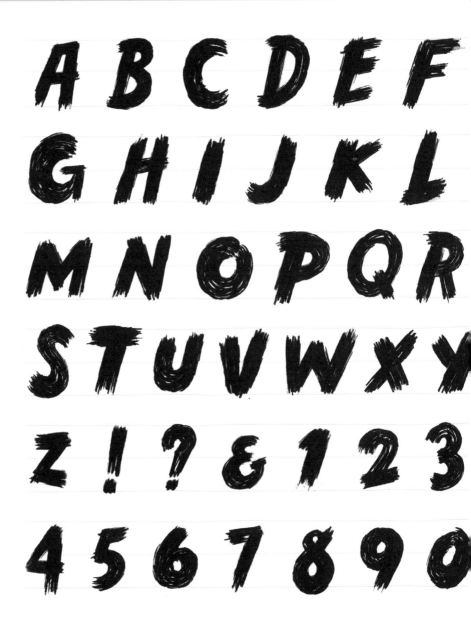

A B C D E F
G H I J K L
M N O P Q R
S T U V W X Y
Z ! ? & 1 2 3
4 5 6 7 8 9 0

YOUR TURN

28 King Lear

"King Lear" is noble enough for old William's stories and, rather than a tragic ending, this alphabet will be a great solution for your next upscale invitation or grand announcement.

CAPITAL CONSTRUCTION

Using a fine-tip pen, draw the skeleton of your letter.

Add weight to your downstrokes only.

Draw in hairline shadow lines, again on the downstrokes only.

Use the pen to fill in the letter to finish.

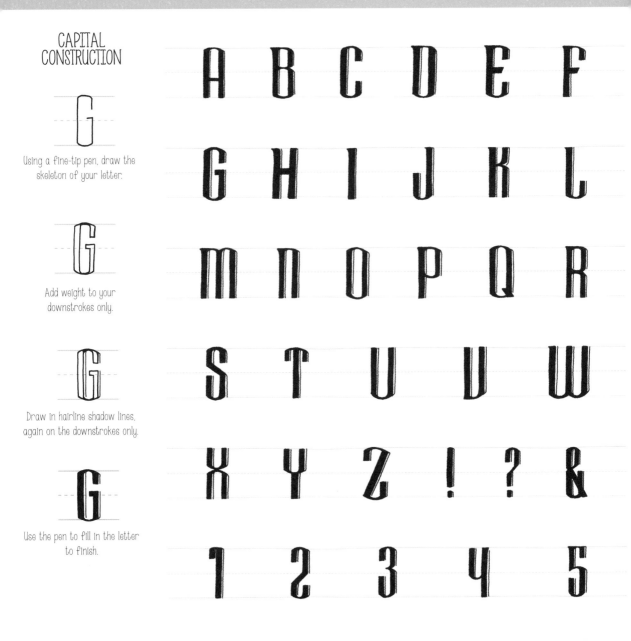

TOOL

- Fine-tip pen

a b c d e

f g h i j

k l m n o

p q r s t

u v w x y z

6 7 8 9 0

LOWERCASE CONSTRUCTION

Using a fine-tip pen, draw the skeleton of your letter.

Add weight to your downstrokes only.

Draw in hairline shadow lines, again on the downstrokes only.

Use the pen to fill in the letter to finish.

TOOL

- Brush pen

29 BRUSHSTROKES

This dynamic alphabet by Casey Ligon breathes life into its letters and imitate the brisk brushstrokes of an artist's signature.

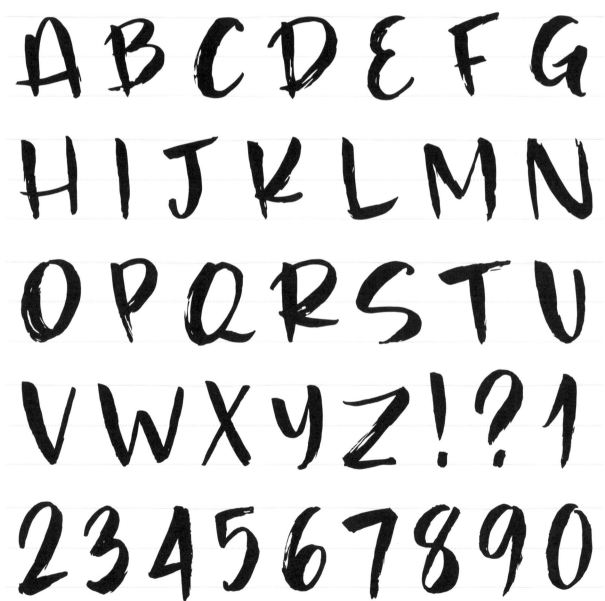

YOUR TURN

TOOL

• Fine-tip pen

30 SHADOWLANDS

Designed by Casey Ligon, this decorative serif has been developed with organic flourishes and light shadow details.

A B C D E F G H I J

K L M N O P Q R S T

U V W X Y Z ! ? &

1 2 3 4 5 6 7 8 9 0

TOOL

- Fine-tip pen

"Epic Story" was made for announcing great romances from times gone by. Think *My Fair Lady* and you'll have the picture spot on. This alphabet was designed by Olga Zakharova for stories with a happy ending.

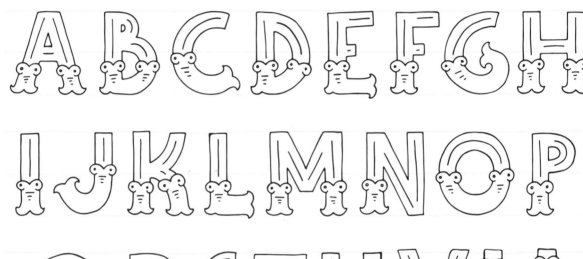

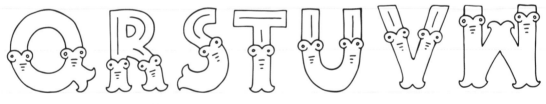

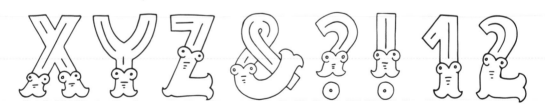

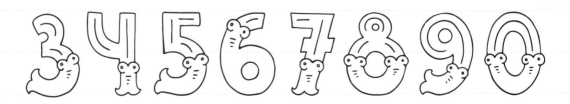

YOUR TURN

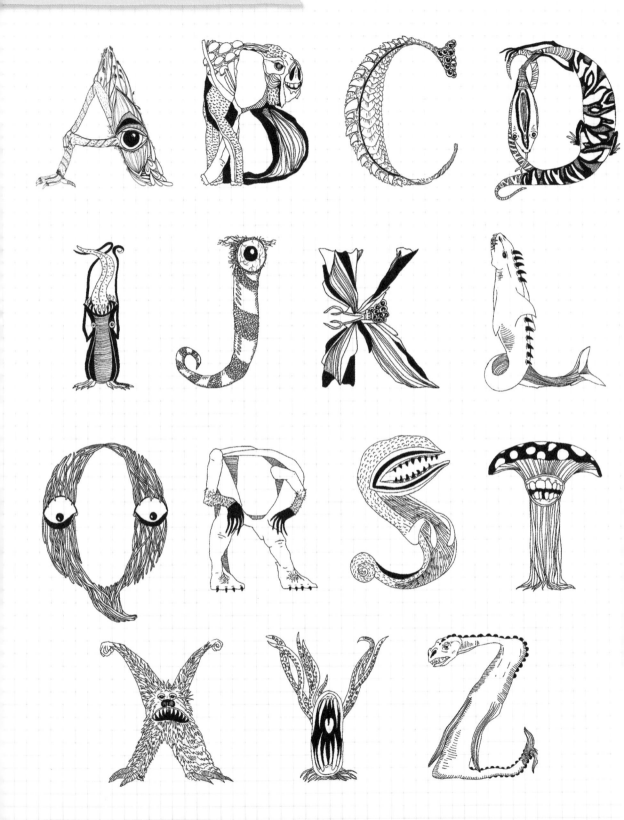

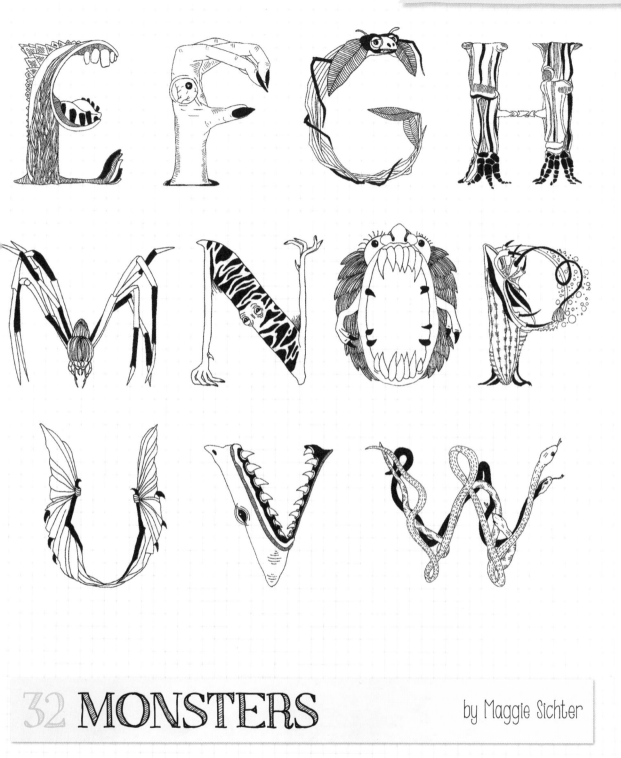

32 **MONSTERS** by Maggie Sichter

TOOLS

• Fine-tip pen

33 ASTER

Jill De Haan describes "Aster" as like the sweet little lady next door who brings you homemade jam and banana bread—endearing, steadfast, and always ready to cheer you up!

BASIC CONSTRUCTION

Draw the basic shape, thicker on the right side.

Draw the crossbar, thicker on the downstrokes.

Add serifs to the top and bottom.

Draw inlines in the thickest areas.

Add a drop shadow to the lower left.

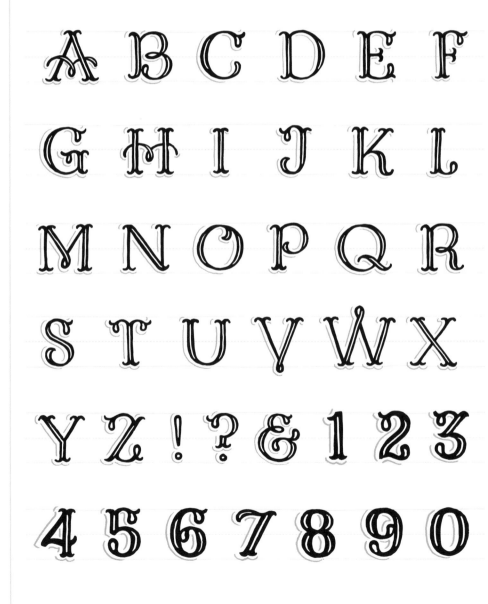

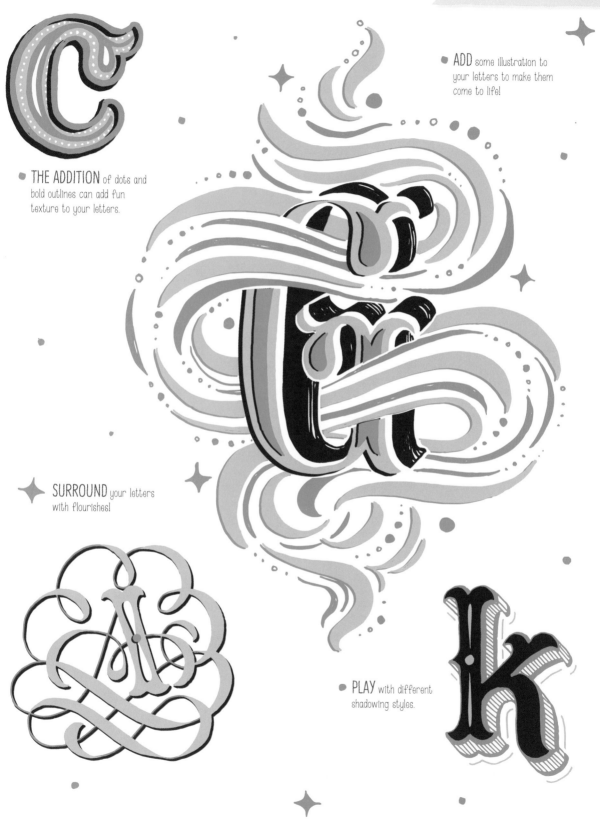

THE ADDITION of dots and bold outlines can add fun texture to your letters.

ADD some illustration to your letters to make them come to life!

SURROUND your letters with flourishes!

PLAY with different shadowing styles.

TOOL

• Fine-tip pen

34 RAVAL GOTHIC

This letter style, inspired by signs from the old Raval barrio in Barcelona, takes us back to the 1960s, when everything, letterforms included, was far simpler and had the bold warmth of the pre-digital era. This alphabet is by Ivan Castro.

BASIC CONSTRUCTION

Draw the thick stem, the width of which should be one-third of the letter height. Pay attention to which stems are thick and which are thin (you can find it in the model).

Draw the thin stems at half the thickness of the thick stem. Make sure that when two stems meet, they overlap. We don't want thin joints.

You can add decorative elements, such as serifs, dots, or lines (see next page for more ideas).

Finally, ink in the letter.

ABCDEFG
HIJKLMNO
PQRSTUV
WXYZ!?&
12345678

90

FEEL FREE TO ADD
DECORATIVE ELEMENTS TO
THE MAIN STRUCTURE OF
THE LETTER, BUT REMEMBER
ONE RULE: DON'T MAKE A
MESS, BUT AIM TO RETAIN
THIS LETTER'S SIMPLICITY.

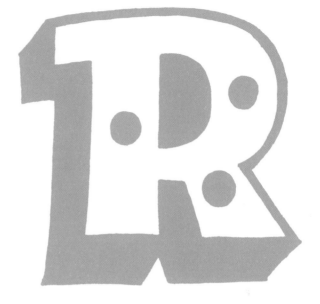

BLOCK SERIFS, drop shadows, and patterns
within the letter are just a few ideas.

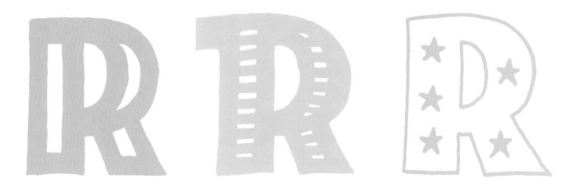

THERE ARE a number of decorative motifs you can add inside the
letters without making them too fussy: inlines, stripes, and stars, for
example. If the patterns are to be negative, make sure you draw their
outlines before inking in.

TOOL

- Fine-tip pen

35 SAILOR TATS

Imagine you're a sailor in the 1940s, and your destination is Honolulu. Imagine what you'll find there: probably something your mom would not approve of. That doesn't mean you can't bring home a little souvenir in your skin. This alphabet is designed by Ivan Castro.

BASIC CONSTRUCTION

Draw the main structure of the letter with a fine-tip pen, paying attention to the placing of the thick and thin stems to achieve a good contrast.

In the terminals, add curvy, bifid serifs.

Add decorative spikes in the center of the stems, and to form the crossbar.

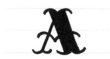

Fill the thick stem with ink.

A B C D E F
G H I J K L
M N O P Q
R S T U V
W X Y Z !
? & 1 2 3 4
5 6 7 8 9 0

EXPERIMENT with the thickness of the strokes. You can even discard the thick part of the letter to make a mono-weight alternative.

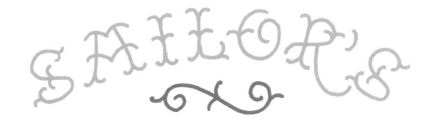

PLAY WITH the inking in of the thick part of the letter, for example inking from the bottom up to the decorative spikes.

IN COMPOSITIONS, add small decorative nautical elements, such as anchors, curls, stars, or rudders, always keeping it simple and with a single line.

TOOL

• Fine-tip pen

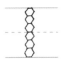

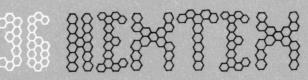

"Hextex" is inspired by the beautiful and fun tile lettering you find in entryways to coffee shops or even in the homes of friends and family. This modular alphabet is quirky and can be used for store posters or party invites.

BASIC CONSTRUCTION

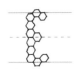

Using a fine-tip pen, draw the stem of the letter with six hexagons, doing your best to keep them the same size.

When you draw in the crossbars, pay attention to the way the hexagons lay next to each other to decide how to execute the shapes.

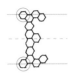

Add hexagonal serifs to the stem for decorative interest.

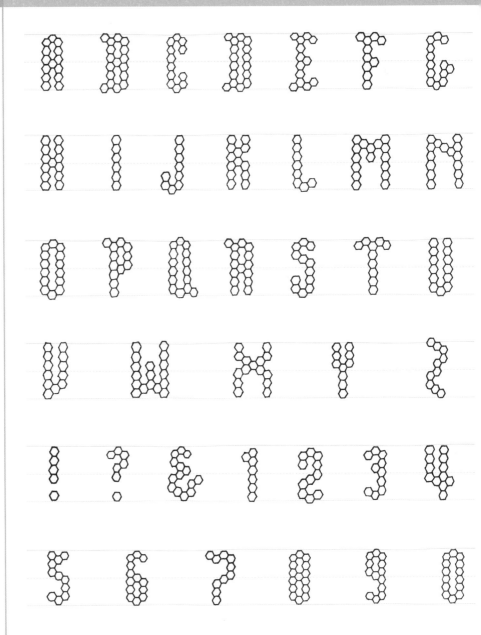

37 ICING

The signpainting community might use these fun, condensed icy caps on ice machines, or something equally frosty. You can use "Icing" for any wintertime graphics, or on a sign for ice creams.

TOOLS

- Pencil
- Fine-tip pen

A B C D E F

G H I J K L

M N O P Q R

S T U V W X

Y Z ! ? & 1 2 3

4 5 6 7 8 9 0

BASIC CONSTRUCTION

Using a pencil, sketch your letter on a slant. The slant can be as extreme as you like.

Add snow piles wherever they would usually form, keeping variation in mind to make them appear more natural.

Finish by using a fine-tip pen to ink the letter. Make sure you don't draw letter lines through your snow piles.

TOOLS

- Pencil
- Fine-tip pen

"D'OH!" is a deliciously playful ode to the donut-loving Homer Simpson. Naturally, this alphabet is perfect for your next donut party, or might even work as a fun album cover.

BASIC CONSTRUCTION

Using a pencil, draw your letter with plenty of fluff.

Frost your letter with icing. This will add some dimension. Keep in mind the angle at which the letter is laying to direct the drips the right way.

Add sprinkles! Be sure to use variety in size and placement to make it look natural.

Finish by inking your letter with a fine-tip pen, avoiding overlapping lines.

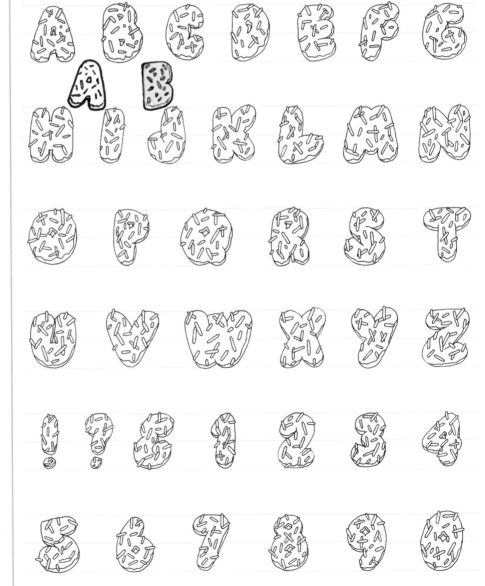

39 SWEET JANE

"Sweet Jane" is the lady that greets you at the corner candy shoppe, with all of the delectable treats displayed behind her in the most beautiful way. This alphabet is perfect for a painted sign or even titling your recipe cards.

TOOL

• Fine-tip pen

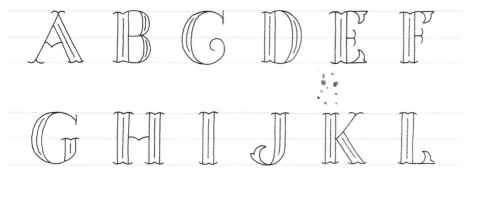

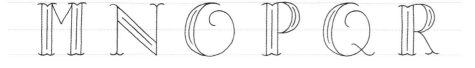

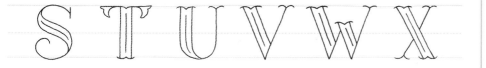

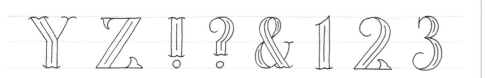

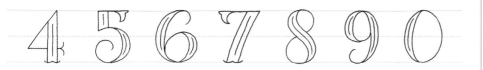

BASIC CONSTRUCTION

Using a fine-tip pen, draw the sides of your stems.

Add some decorative serifs.

Add a crossbar in the same style as the serifs.

Finish by adding simple inlines.

40 FLORAL

by Maggie Sichter

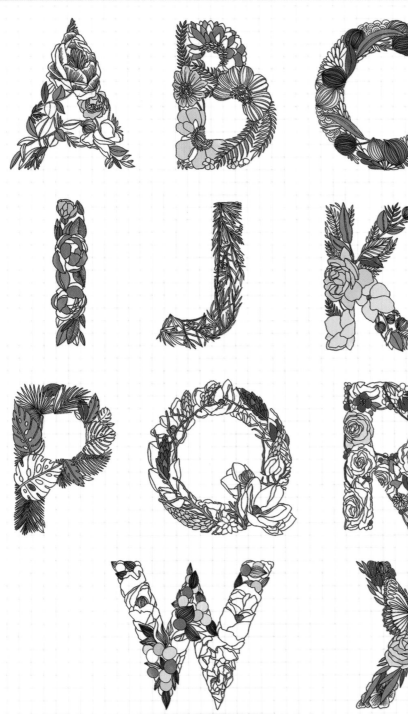

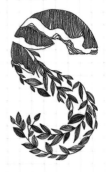

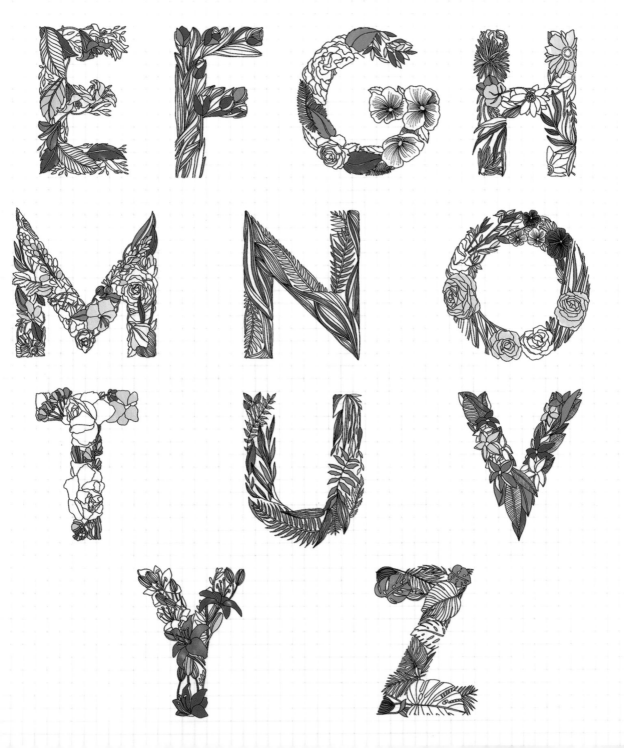

41 Mamma Mia

A nod to the musical and happy-go-lucky songs it features, "Mamma Mia" is feminine and sweet, and perfect for your girl's-night invitations or for lettering names on gifts.

CAPITAL CONSTRUCTION

Using a fine-tip pen, draw the skeleton of your letter.

Add weight to your letter, keeping it somewhat evenly thick, with the exception of the tapered top of the stem.

n

Use the pen to ink in the letter.

A B C D E F
G H I J K L
M N O P Q R
S T U V W
X Y Z ! ? &
1 2 3 4 5

TOOL

- Fine-tip pen

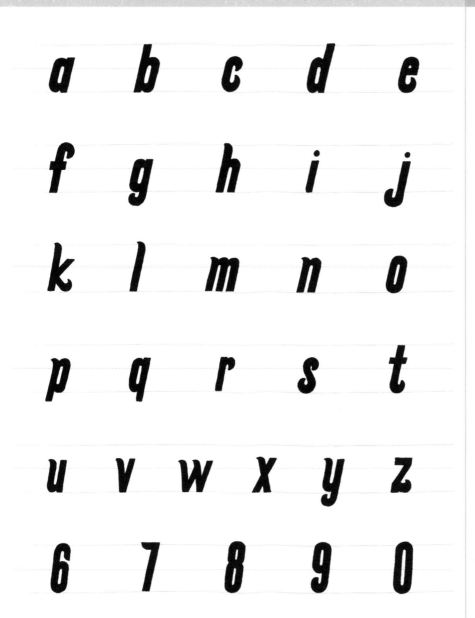

a b c d e

f g h i j

k l m n o

p q r s t

u v w x y z

6 7 8 9 0

LOWERCASE CONSTRUCTION

Using a fine-tip pen, draw the skeleton of your letter.

Add weight to your letter, keeping it somewhat evenly thick, with the exception of the tapered top of the stem.

Use the pen to ink in the letter.

TOOL

- Fine-tip pen

 POW!

"Pow!" is a standout letterform, intended to give visual punch. It is quirky and adds to any statement that needs to really shout off the page. This alphabet is perfect for invitations to a retro 1980s' party, or use it to make an exciting sign that roots for your team.

BASIC CONSTRUCTION

Use a fine-tip pen to draw the basic skeleton.

Add a horizontal line to create two overlapping triangles.

Fill in your letter to finish.

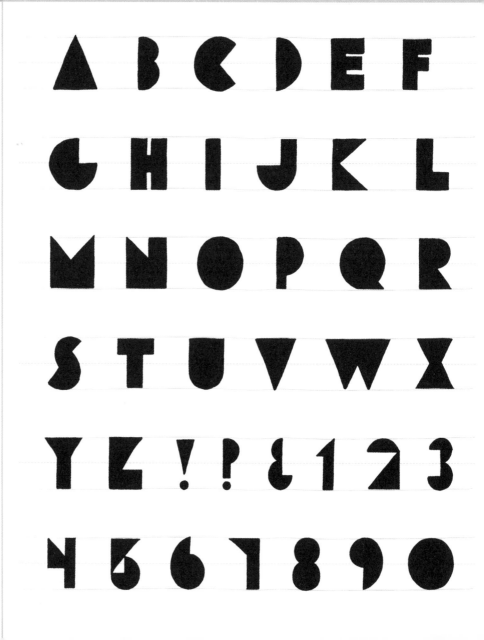

POW!

Mama Mia
Mama Mia

TOOLS

- Pencil
- Fine-tip pen

43 MAUDE

"Maude" brings back fond memories of that grandmother with blush pink roses on her wallpaper, and the intense powdery scent of her perfume. Channel her essence with this delicate but sweet alphabet.

BASIC CONSTRUCTION

Make a pencil sketch of the outline of the letter.

Add bracketed serifs.

Draw in some decorative florals.

Ink the letter outline wherever there aren't any floral elements.

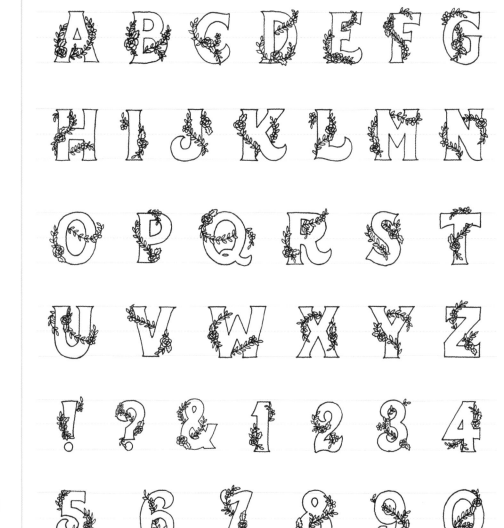

ADDING MORE TO DECORATIVE
LETTERS IS A FUN EXERCISE
IN BALANCE AND DETAIL.
WHEN DONE RIGHT, YOUR
LETTERS HAVE ADDED BEAUTY
AND CAN STILL BE LEGIBLE

TRY weaving in a
different kind of leaf
from the ones you use on
your vines, to create
some variety.

ADD some interest to your letters with decorative elements,
such as a dot inline or lines to imply shadows.

THE STYLE of the arrangement can easily
change with different kinds of vines. You can
even use more than one, but be careful of
overdoing it.

USE one or two kinds of
flowers to create a lovely
visual bouquet.

44 Ferry

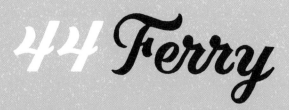

"Ferry" is like a pleasant summer afternoon on the pier. It is a friendly and flirty, casual script that will breathe life into any hand-painted sign or beach party flyer. This alphabet is created by Jill De Haan.

CAPITAL CONSTRUCTION

Using a brush pen, draw a capital 'C' at the same angle as your slanted lines. Press harder on the downstroke to create the thicker line.

Now draw your stem. Keep it a steady thickness until you reach the bottom.

Add your spur, which should be thick at the top and thin where it meets the stem.

A B C D E

F G H I J

K L M N O

P Q R S T

U V W X

Y Z ! ? &

holiday

m m d

a b c d e f

g h i j k l

m n o p q r

s t u v w x

y z 1 2 3 4

5 6 7 8 9 0

TOOL

• Brush pen

LOWERCASE CONSTRUCTION

With the brush pen, make a small upward spur, followed by a thick downstroke.

Repeat this a second time.

And a third time.

Finish with a decorative spur.

45 ANIMALS

by Amy Rogstad

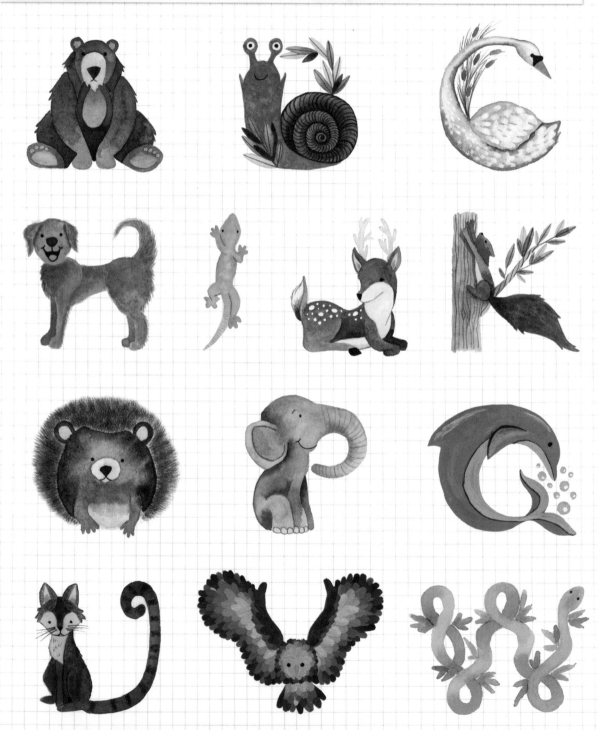

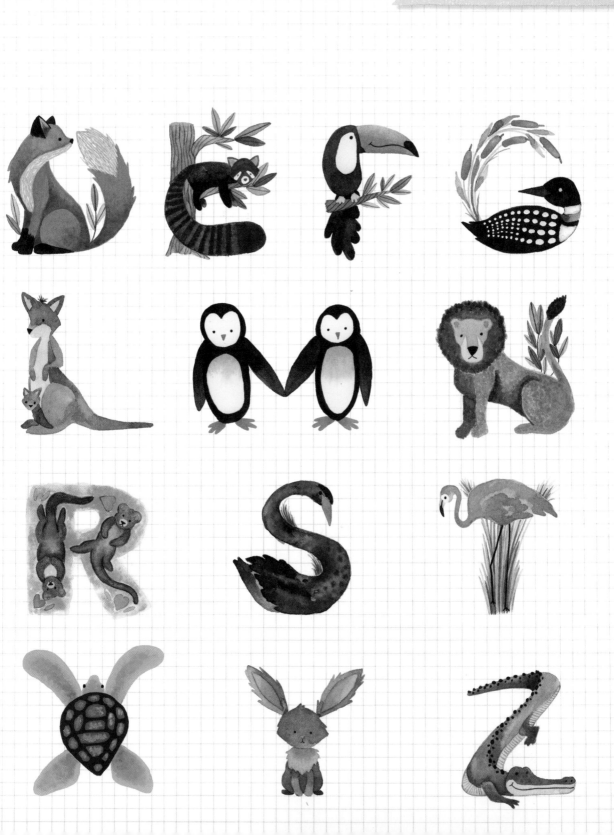

TOOL

- Chisel-tip pen

46 FREAKSHOW

"Freakshow" is far from freakish, but instead is inspired by old-fashioned circus and freakshow playbills. Your message can easily be made more dramatic by adding to the details.

BASIC CONSTRUCTION

Draw the basic shape with the tip of the pen to create the thin lines.

Add decorative serifs that start like a slab but then dip where the middle meets the stem.

Embellish even further with some diamonds on the stems.

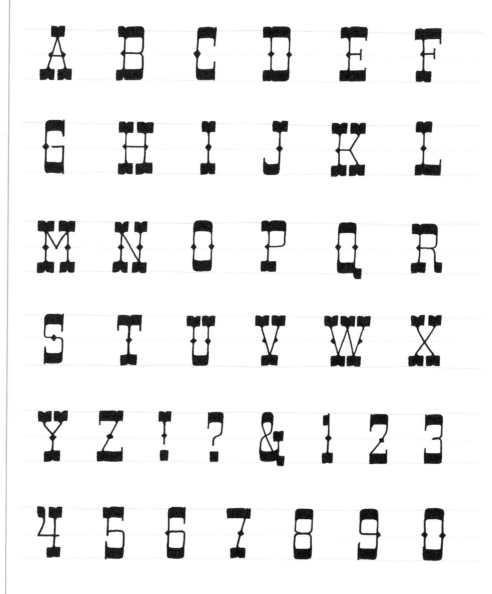

DECORATIVE ORNAMENTS AND FILIGREE
CAN BRING EXCITEMENT TO ANY LETTER
THAT ALREADY HAS CHARACTER.

ADDING ORNAMENTS Is a great way to boost character. Use them In or around the letter, or both, to create dynamic combinations.

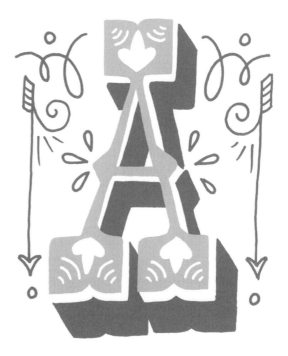

USE filigree to fill out a composition around your letter. It can be elaborate or simple in nature.

TOOL

- Fine-tip pen

47 BLING

This alphabet is all about the bling. With its chiseled dimensions it is sure to up the value of any piece of writing, and can be used for anything from a party invite to make-believe bank bills.

BASIC CONSTRUCTION

Using a fine-tip pen, draw the shape of the letter.

Add triangles to serve as the starting points of the dimension of your letter.

Define the dimension of the crossbar so it will help guide how you create the stems. Note: the angle you use echoes the ones of your triangles.

Complete the dimensional lines for the stems.

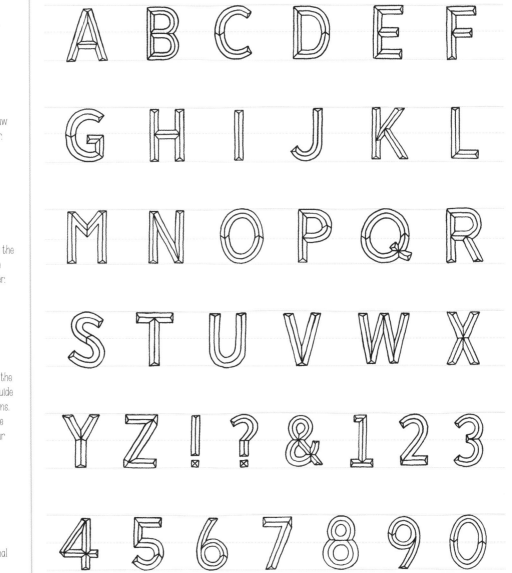

A B C D E F
G H I J K L
M N O P Q R
S T U V W X
Y Z ! ? & 1 2 3
4 5 6 7 8 9 0

happy

holiday

holiday

holidays

TOOL

- Fine-tip pen

48 PICNIC

Like a day-off in the park, "Picnic" takes you to a place where the sun is shining, you are running around barefoot, and your cheeks start to hurt from smiling. This alphabet is designed by Olga Zakharova.

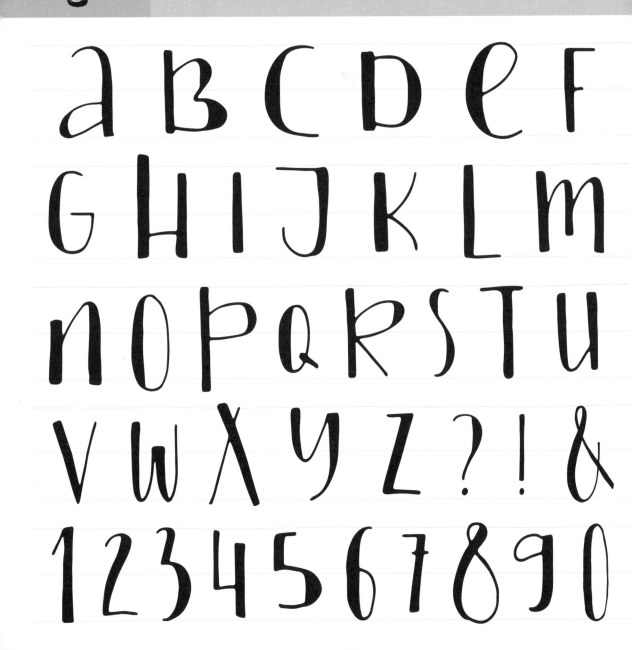

YOUR TURN

R

TOOL

- Fine-tip pen
- White paint marker

49 CASSETTE

Celebrating the compact cassette tapes of the 1970s and 80s, "Cassette" will add some fun to your next album-cover design or event poster.

BASIC CONSTRUCTION

Using a fine-tip pen, draw the outlines of the letter. Note that the crossbar falls below the midline.

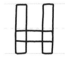

Fill in the letter.

To finish the letter, use a white paint marker to add some inlines.

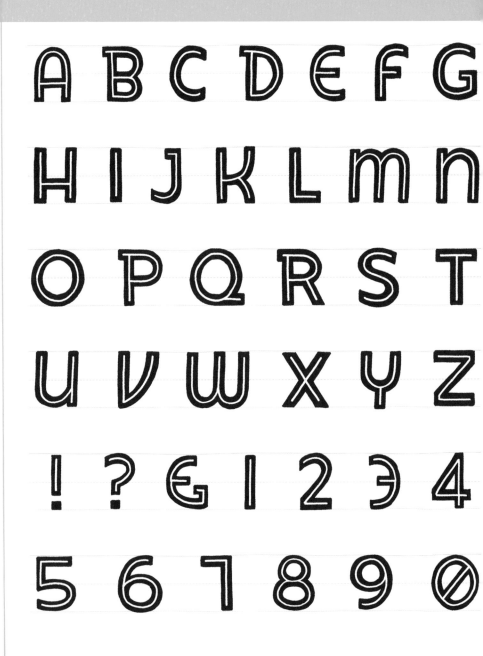

YOUR TURN

50 FOOD

by Olga Zakharova

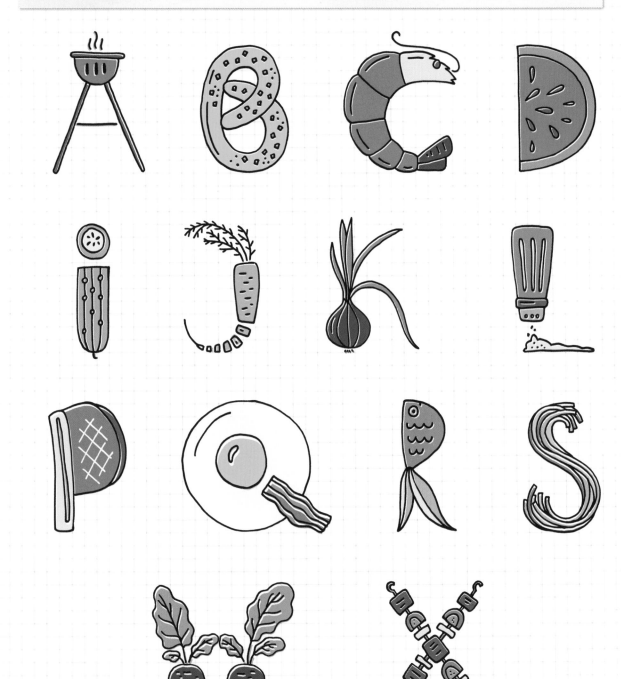

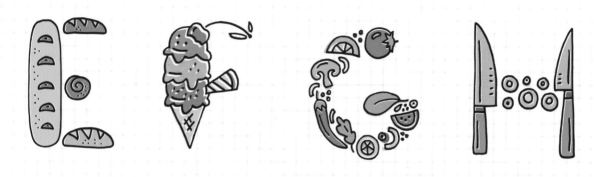

PUNCTUATION

This section features a variety of accents for a selection of the alphabets in this book so that you can write words in different languages. There are also some common punctuation marks. Indicated next to each set of marks are the alphabets they are designed to be used with.

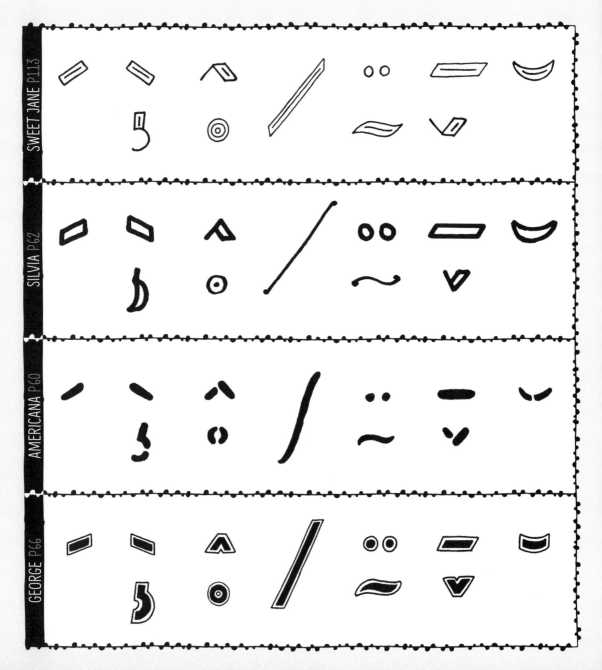

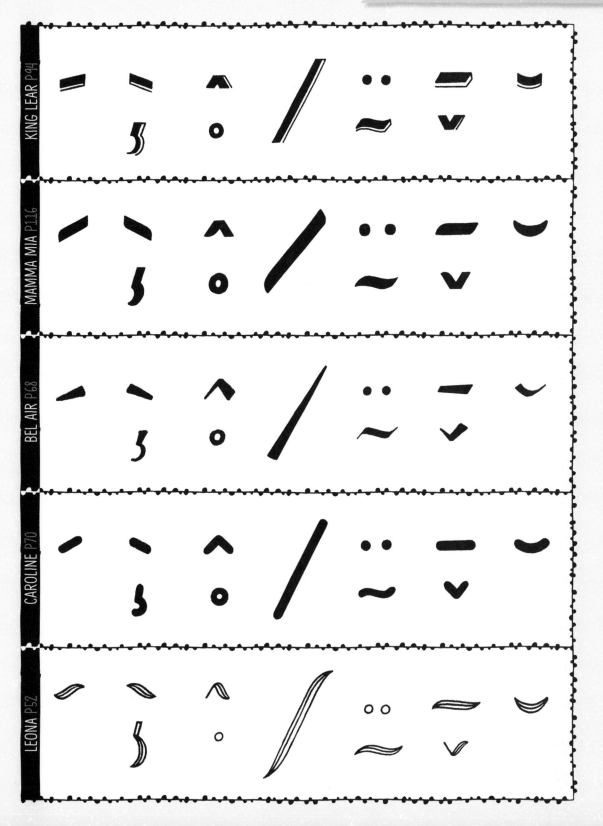

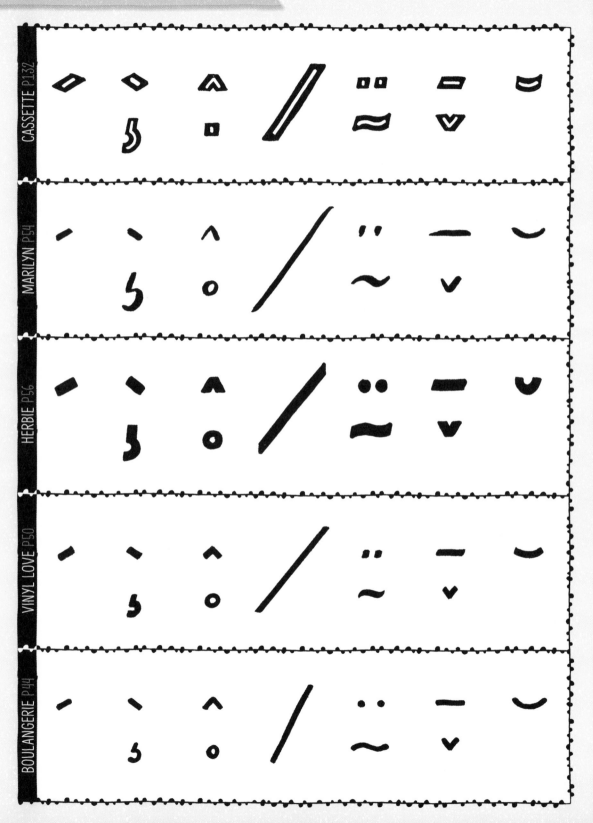

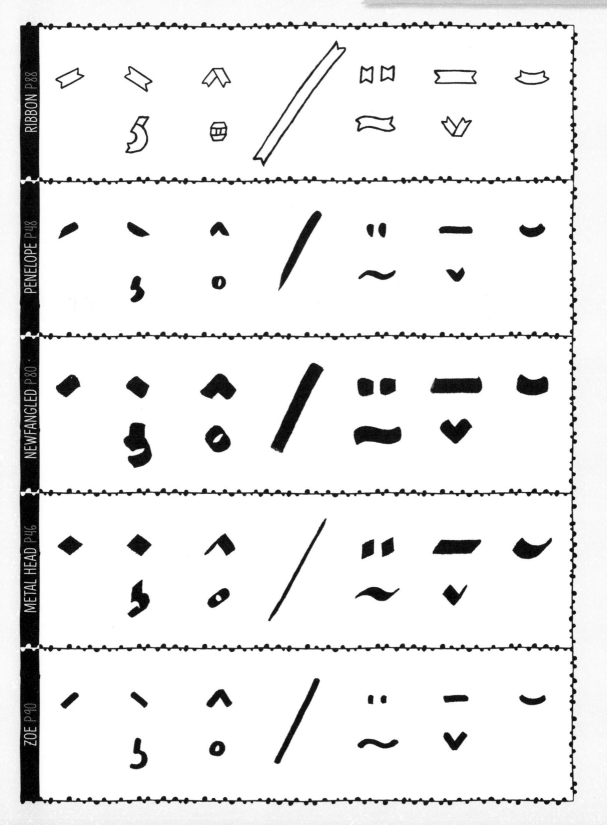

MEET THE CONTRIBUTORS

IVAN CASTRO

JILL DE HAAN

CASEY LIGON

AMY ROGSTAD

Ivan Castro is a graphic designer based in Barcelona, Spain, who specializes in calligraphy, lettering, and typography. His work involves everything from advertising to editorial, and from packaging to logo design and gig posters. Ivan has been working in the field for 15 years, and teaching calligraphy and lettering at the main design schools in Barcelona for 10 years. He travels frequently, holding workshops and giving lectures at design festivals and conferences.

www.ivancastro.es

Jill De Haan is an old soul who loves embroidering handkerchiefs, sipping on cups of tea, and perusing consignment stores. She specializes in lettering and illustration and loves exploring different mediums in both of these areas. She lives in the mountains of Utah with her husband, baby boy, and tiny dog.

www.jilldehaan.com

Casey Ligon is a graphic illustrator currently based in Florida. After receiving her BFA from Ringling College, Casey began working as a copywriter at Hallmark. She went on to join their marketing department, where she learned traditional calligraphy and hand-lettering techniques. Casey now works freelance from her North Florida studio, collaborating with some of the most prolific brands and agencies from all over the world.

www.caseyligon.com

Amy Rogstad is a graphic designer by day, and an illustrator by night. Currently based in Minneapolis, she initially began selling her wonderful illustrations online as a complement to her day job. She creates unique illustrations and lettering with a nature theme, as well as custom watercolor illustrations, which are available at her online store.

www.fercute.com

MAGGIE SICHTER

Maggie Sichter is an illustrator based in Chicago. Maggie worked as an Art Director in the tech start-up industry before developing her passion for drawing into a full-time career. She specializes in illustrations for packaging, textiles, and branding. Her designs are incredibly intricate and detailed, leaning toward nature-inspired, geometric styles.

www.littlepatterns.com

ALEXANDRA SNOWDON

Alexandra Snowdon is an illustrator and printmaker specializing in hand lettering. After working as a graphic designer and traveling across the world, Alexandra attained a first-class degree in Illustration and went on to launch her own design company, Snowdon Design & Craft, where she creates her unique and delightful prints and cards.

www.snowdondesignand craft.com

ABBEY SY

Abbey Sy is an artist and author based in Manila, Philippines, who specializes in hand lettering and travel illustration. She currently juggles freelance work with teaching art classes, and producing her own merchandise, in the hopes of further fueling her passions and inspiring others to "always be creating."

www.artistic-dreams.com

OLGA ZAKHAROVA

Olga Zakharova is a Russian-born graphic designer, illustrator, and letterer currently living in Latvia. Alongside her husband and a morning coffee, Olga loves creating fonts and lettering and has recently begun developing her passion for illustrated city maps.

www.en.zakharovaolga.ru

INDEX

CREDITS

Quarto would like to thank the following artists for supplying images for inclusion in this book:

- Alex Hubenov/Shutterstock.com, p.27t/c/b
- Biernat, Tomasz, www.tomaszbiernat.us, pp.12, 13
- Biersack, Scott, www.scottbiersack.com, p.11
- Callahan/Shutterstock.com, p.27t/r/b
- Camp, Noah, www.letteringcamp.com, p.18t/b
- Castro, Ivan, www.ivancastro.es, p.14t/b
- Chelsea Scanlan Photography, www.chelseascanlan.com, p.6t/b
- David P. Smith/Shutterstock.com, p.27b/l/t/t
- Delosh, Diana Ting, http://dianadelosh.com, p.19
- Emka74/Shutterstock.com, p.27b/r/t
- Emka74/Shutterstock.com, p.27t/l/c
- Flor, Martina, www.martinaflor.com, p.15
- J.D.S/Shutterstock.com, p.27t/c/t
- Jones, Jonelle, www.jonellejones.com, p.20
- Jorome/Shutterstock.com, p.27b/c/c
- LittleMiss/Shutterstock.com, p.27t/l/b
- Mr Doomits/Shutterstock.com, p.27b/l/b
- Mr Doomits/Shutterstock.com, p.27t/r/t
- Mullan, Michael, www.mullenillustration.com, p.16
- Nrey/Shutterstock.com, p.27b/r/t
- Pio3/Shutterstock.com, p.27b/c/b/b
- PremiumVector/Shutterstock.com, p.27b/c/t
- Robnroll/Shutterstock.com, p.27b/l/b/b
- Skerratt, Emma, www.emmaskerratt.co.uk, p.17
- Snowdon, Alexandra, www.snowdondesignandcraft.com, p.22
- TFoxFoto/Shutterstock.com, p.27b/l/t
- Thinglass/Shutterstock.com, p.27t/c/c
- Wöhrmann, Petra, www.petrawoehrmann.com, p.14t
- Zakharova, Olga, http://en.zakharovaolga.ru, pp.10, 23

t: top, **b:** bottom, **c:** center, **l:** left, **r:** right. (E.g. **b/r:** bottom right)